IMAGES
of America

HISTORIC DALLAS
THEATRES

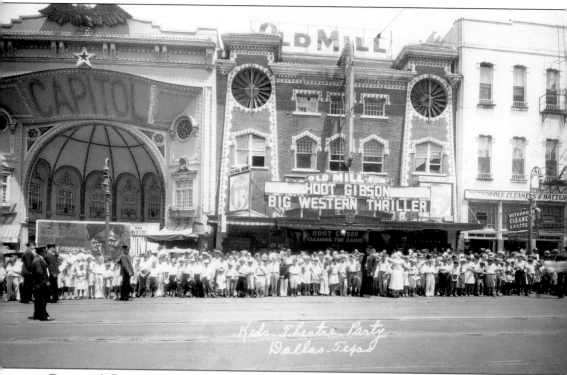

Keds Theatre Party
Dallas, Texas

CHILDREN'S PARTY, 1525 ELM STREET. Radio station WRR sponsored this "kid party" on June 13, 1931, as a promotion for its long-running "Kiddie Show" broadcasts on Saturday mornings. It is difficult to believe there was ever a time when parents could let their preteens ride a streetcar downtown for an afternoon at the movies without worry; it is difficult to remember a time when kids could derive such joy and satisfaction from simple pleasures, like a movie and penny candy. This photograph is proof that such a time existed. (Courtesy Mary McCord/Edyth Renshaw Collection on the Performing Arts, Jerry Bywaters Special Collections, Hamon Arts Library, Southern Methodist University.)

ON THE COVER: OLD MILL THEATRE INTERIOR, 1931. Each child's face tells a unique story. All lived lives before and after this photograph—some successful, some tragic, others unremarkable. Wars, disease, and accidents ended some far too soon, and only a handful survives today—aged 90 or more. However, in the split second captured here, each was happy, excitedly anticipating the show to come. (Courtesy Mary McCord/Edyth Renshaw Collection on the Performing Arts, Jerry Bywaters Special Collections, Hamon Arts Library, Southern Methodist University.)

IMAGES
of America

HISTORIC DALLAS THEATRES

D. Troy Sherrod

ARCADIA
PUBLISHING

Published by Arcadia Publishing
Charleston, South Carolina

Printed in the United States of America

Library of Congress Control Number: 2013949944

For all general information, please contact Arcadia Publishing:
Telephone 843-853-2070
Fax 843-853-0044
E-mail sales@arcadiapublishing.com
For customer service and orders:
Toll-Free 1-888-313-2665

Visit us on the Internet at www.arcadiapublishing.com

*Dedicated to my mother, Yvonne B. Sherrod, for encouraging
my imagination and trips to the movies; to my grandmother
Joy Harris Boatman Haws, for stories of Dallas past*

CONTENTS

ACKNOWLEDGMENTS

Special thanks must go to the staff of the Special Collections at Hamon Arts Library, Southern Methodist University: Ellen Buie Niewyk, Sam Ratcliffe, and especially Emily George Grubbs for her generosity, patience, and enthusiasm.

Thanks also for the assistance and contributions of Bob Johnston, Randy A. Carlisle, Jim Wheat, Bryan McKinney, and Adrianne Pierce, Texas/Dallas Archives, Dallas Public Library; Jerome Sims, *Dallas Morning News*; Pamalla Anderson, DeGolyer Library, Southern Methodist University; Mary Katherine McElroy, Texas Theatre; Lisa Schreiner Goss and Robyn Flatt, Dallas Children's Theatre; Teresa Coleman Wash, TeCo Theatrical Productions, Inc.; Chris Schull, Dallas Symphony Orchestra; Chris Heinbaugh and Drew Eubank, AT&T Performing Arts Center; Cora Cardona, Teatro Dallas; and Samantha Dodd, Dallas Historical Society.

Additional thanks to my aunt Carol Tucker for sharing her expertise of the horror genre; to Brenda S. Prothro (my theatre teacher) and Troupe 2063 of the International Thespian Society for recognizing and developing my theatrical spirit, even to this day; and to Philip Wuntch for noticing and interviewing the fat kid with the cheap camera taking photographs of the Wilshire Theatre on its closing day.

Thanks also to Julie Travis, retired librarian of the Dallas Public Library's film department, for recognizing a fellow film buff and giving a kid of 19 one of the best jobs he has ever had; to Sandra Setnick Zucker and Southern Methodist University for assisting me to obtain a great college education I could have never afforded otherwise; to all my amazing professors, especially C.W. Smith, Charles Davis, Camille Kraeplin, Michael Hazel, and Martha Selby; and to all those I might have neglected to name.

Finally, thanks to Arcadia Publishing for the making this book possible, and to editor Laura Bruns for her infinite patience and enthusiasm.

INTRODUCTION

Once upon a time, in the not so distant past, communities everywhere gathered—regardless of creed or politics—and, together, we escaped the woes of the world in temples dedicated to our hopes and dreams. For two bits, we held court in exotic grandeur—amid the celestial—losing ourselves inside images illuminated on a silver screen, and while a thousand stars shimmered above our heads, in the company of strangers, we were reminded of how so many hopes and dreams were shared ones.

Speak the magical words: the Majestic, the Palace, the Rialto. Behold the spell that is cast on those who hear. These theatres are beloved icons of an innocent, romantic, and wondrous age of possibility. These theatres are part of those who ever entered.

Memories—the loves that blossomed, the tears shed, the laughs shared. For one fleeting, shining moment, a thousand souls became as one within these structures of white marble and red velvet.

The poetry is nearly lost. Sometime in the recent history of the world, we traded our past for a parking lot and a quick buck. Sentimentality, romance, and beauty became hackneyed ideas replaced by sarcasm, cynicism, self-centeredness, and greed. Television—mindless, commercial, yet intimate—has isolated us in lifeless living rooms.

Only a handful of our theatres remain, many perilously close to their demise. The Majestic Theatre was rescued by a few people who cared, leading the way. It is my hope that this book will educate readers about what we have had, what we have lost, and what is left to be preserved.

One

THE EARLY YEARS

CIRCUSES AND TRAVELING
SALESMEN. Traveling
circuses were most likely
the earliest professional
theatrical productions to
entertain the people of
Dallas. This advertisement
for Orton & Older's Great
Southern Circus appeared
in an 1859 *Dallas Herald*.
A more common source of
entertainment was certain
peddlers, particularly the
iconic "snake oil" salesman,
who often provided some
sort of attraction—jugglers,
exotic animals, magic tricks,
and so on—to draw a crowd
to whom he could hawk
his wares. (Courtesy Dallas
Public Library, NewsBank.)

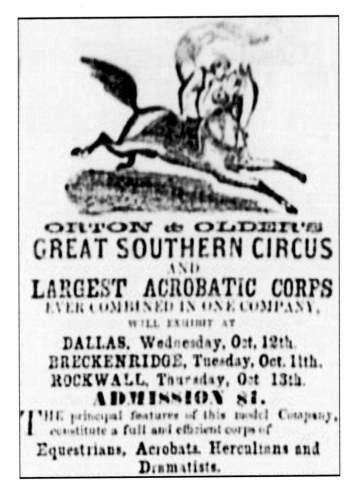

ORTON & OLDER'S
GREAT SOUTHERN CIRCUS
AND
LARGEST ACROBATIC CORPS
EVER COMBINED IN ONE COMPANY,
WILL EXHIBIT AT
DALLAS, Wednesday, Oct. 12th.
BRECKENRIDGE, Tuesday, Oct. 11th.
ROCKWALL, Thursday, Oct 13th.
ADMISSION $1.
THE principal features of this model Company,
constitute a full and efficient corps of
**Equestrians, Acrobats, Herculeans and
Dramatists.**

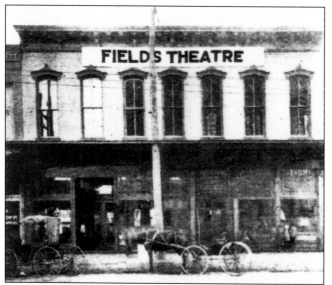

SOUTH SIDE OF MAIN STREET, BETWEEN AUSTIN AND LAMAR STREETS. J.Y. and Thomas Field opened Dallas's first legitimate theatre building on October 27, 1873, to a sold-out house. It was primitive, with a raised stage, scenery rigging, no dressing rooms, and folding chairs for the audience. It doubled as a roller rink when no show was in town. Despite its shortcomings, the Field's Theatre was popular until Craddock's Theatre opened in 1879. It was later demolished. (Courtesy Texas/Dallas Archives, Dallas Public Library.)

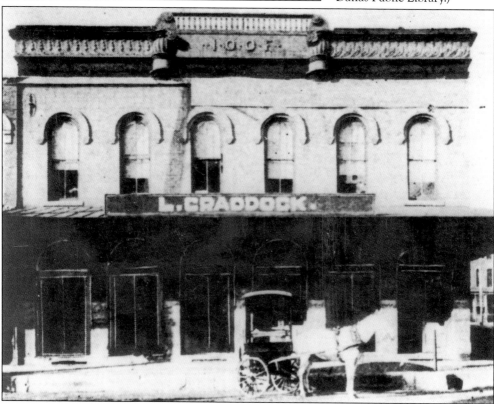

MAIN AND AUSTIN STREETS, NORTHEAST CORNER. In 1879, L. Craddock erected this building housing his wholesale liquor business on the first floor and a 430-seat theatre on the second. The stage measured 20 feet by 25 feet; the dressing room measured 6 feet by 6 feet. Craddock's Theatre presented top actors, such as Edwin Booth, John Templeton, and Maurice Barrymore, to sold-out audiences before closing around 1889. It was later demolished. (Courtesy Texas/Dallas Archives, Dallas Public Library.)

MAIN AND MARTIN STREETS.
Thompson's Variety Theatre
opened in 1872 at 444 Jefferson
Street and later relocated to Main
Street. Deplored by churchgoers
and the upper crust, variety
theatres served alcohol, presented
bawdy entertainment, and thrived
with working men. Other variety
theatres, including the Mascotte,
Gem, Mill's, Camp Street, and the
Pavilion, operated over the next
30 years until a city ordinance
prohibited such establishments.
Thompson's closed around 1890
and was later demolished. (Courtesy
DeGolyer Library, Southern
Methodist University, Collection of
Dallas Morning News Negatives.)

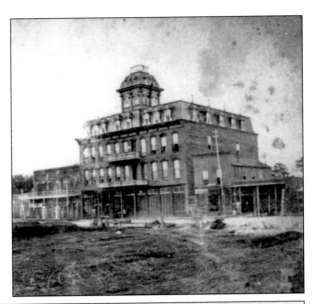

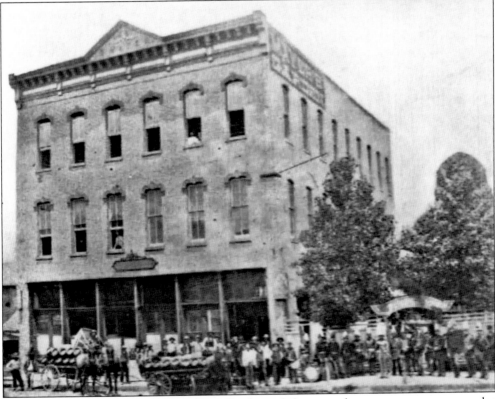

ELM AND STONE STREETS. Mayer's Beer Garden, while not a theatre per se, was a popular entertainment destination throughout the 1880s and 1890s. A nickel bought a glass of beer and an authentic German brass band and novelty acts. The newly invented saxophone debuted in Dallas at Mayer's in 1883. Other popular beer gardens included Meisterhans' on Bryan Street and Little Germany on Ervay Street. By 1908, beer gardens faded into Dallas history. All have been demolished. (Courtesy Texas/Dallas Archives, Dallas Public Library.)

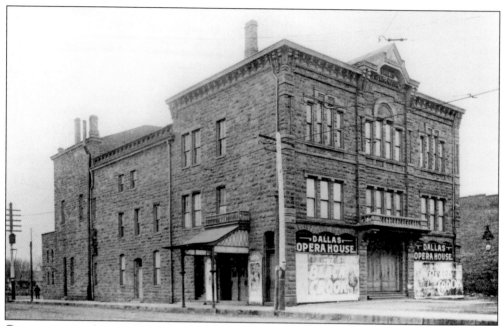

COMMERCE AND AUSTIN STREETS, SOUTHEAST CORNER. The Dallas Opera House opened in the fall of 1883 with enormous fanfare. Built at a cost of $43,000 (equivalent to more than $1 million today), the opera house seated 1,200 and included a parterre, galleries, and a 45-by-60-foot stage. It reigned supreme as Dallas's premier theatre before burning in the early morning of April 25, 1901. Construction on a new opera house began almost immediately. (Courtesy Texas/Dallas Archives, Dallas Public Library.)

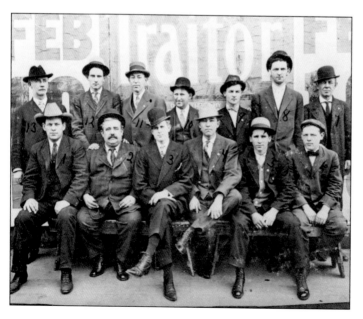

ORIGINAL STAGE CREW, DALLAS OPERA HOUSE. In contrast to the Texas of today, many labor unions were favored among most tradesmen and held large memberships. By about 1908, Dallas stage workers and musicians were unionized, and most Dallas theatres operated with union contracts. (Courtesy Mary McCord/Edyth Renshaw Collection on the Performing Arts, Jerry Bywaters Special Collections, Hamon Arts Library, Southern Methodist University.)

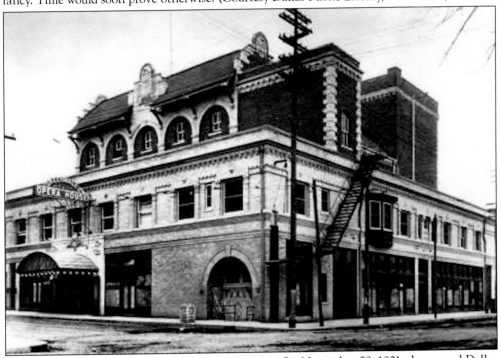

DALLAS OPERA HOUSE.

Edison's Latest and Greatest Wonder

THE VITASCOPE,

MARVELOUS MOTION PICTURES.

Will give three daily exhibitions commencing Sunday. Oct. 11 to 25, mornings 10:30, afternoons 3, evenings 8 o'clock. See X-Rays and Edison's Wonderful Flouorscope on exhibition all day and evenings.

Admission 25 cents to all parts of the house.
WAINWRIGHT & ROCK, Sole Owners and Managers.

THE VITASCOPE, 1896. In 1894, the Dallas Opera House acquired several Kinetoscopes—Edison's hand-cranked machines enabling one person at a time to view moving pictures. With the purchase of Edison's new Vitascope, the opera house was the first to project motion pictures to a Dallas audience on October 11, 1896. Though very lucrative, movies were thought to be only a passing fancy. Time would soon prove otherwise. (Courtesy Dallas Public Library, NewsBank.)

MAIN AND ST. PAUL STREETS, NORTHEAST CORNER. On November 29, 1901, the second Dallas Opera House opened. It featured six boxes and two balconies. The sumptuous decor was illuminated by 1,463 electric lights and consisted of deep-red walls, 1,800 seats of dusty rose, and parquet floors. The opera house organization ceased operation in 1917, but the building housed two more theatre companies before it, too, was destroyed by a fire on December 27, 1921. (Courtesy Texas/ Dallas Archives, Dallas Public Library.)

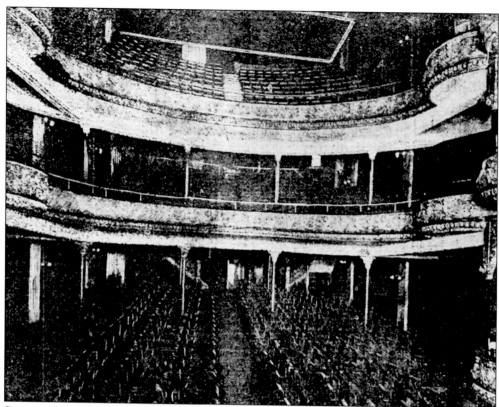

SECOND DALLAS OPERA HOUSE AUDITORIUM. This photograph accompanied a *Dallas News* description of the theatre's ornate decoration: "The rich plaster work . . . finished in gold, with background of delicate cream on which appeared the masques of muses, heads of satyrs and the shapes of musical instruments of the heathen deity Pan . . . invested the shadowy space behind the curtain with the atmosphere of mysticism and the supernatural." (Courtesy Dallas Public Library, NewsBank.)

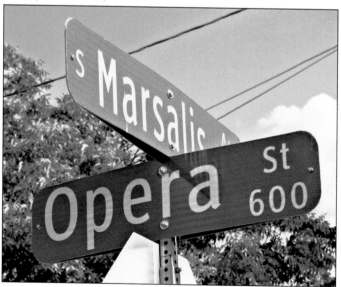

MARSALIS AVENUE AND OPERA STREET. Oak Cliff's first theatre, the Opera Pavilion, opened on June 10, 1889. The MacCollin Opera Company performed *Falka*. Located in Oak Cliff Park (later renamed Marsalis Park, home of the Dallas Zoo since 1922), it thrived every summer until America's Panic of 1893 bankrupted its primary benefactor, the "Father of Oak Cliff," Thomas Marsalis. All that remains today is a one-block street named Opera. (Photograph by author, 2013.)

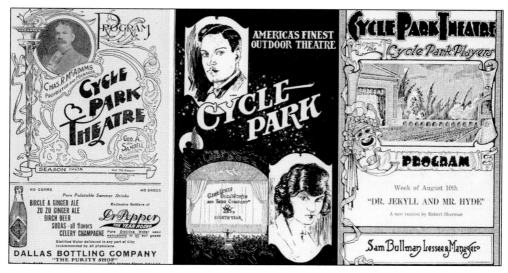

3516 PARRY AVENUE. Across the street from Fair Park, Cycle Park opened on October 12, 1896, as a bicycle racing track and grandstand. When the bicycle craze of the 1890s began to die down, George W. Loomis leased the park and replaced the wooden racetrack with a stage and thus created the Cycle Park open-air theatre, which opened on May 2, 1898, with a program of "high-class vaudeville." The 2,800-seat theatre was soon presenting quality dramatic plays with its own company of stock players. In 1915, it relocated to the corner of Second Avenue and Gunter Street, where it remained until closing around 1920. (Both, courtesy Mary McCord/Edyth Renshaw Collection on the Performing Arts, Jerry Bywaters Special Collections, Hamon Arts Library, Southern Methodist University.)

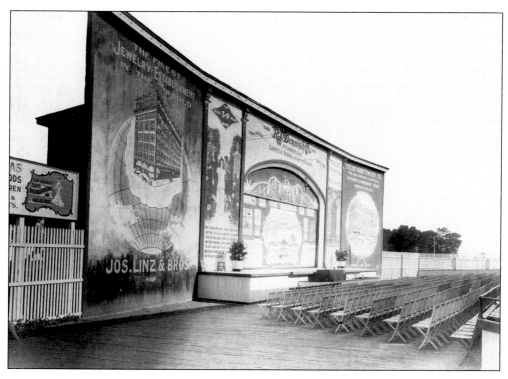

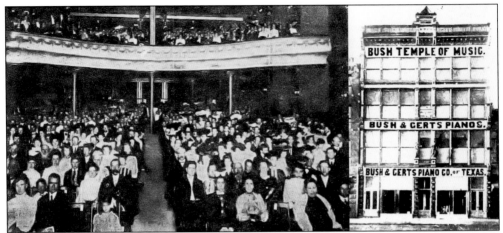

1311 ELM STREET. When Chicago's Bush-Gerts Piano Company built a Dallas sales showroom, it included offices and practice rooms for music teachers on the top two floors, a 750-seat theatre (called the Bush Temple of Music) on the second, and a sales floor on the street level. The theatre opened on December 2, 1903, with a performance by the Boston Ladies' Symphony Orchestra. It was popular for small theatrical productions, lecturers, and recitals before being destroyed by a fire on January 20, 1932. (Author's collection.)

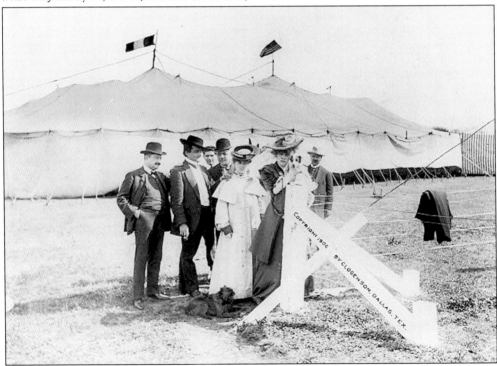

TENT SHOWS. Aside from circuses, tents were sometimes used for vaudeville, movies, and, infrequently because of the terrible acoustics, for serious dramatic productions. When the legendary Sarah Bernhardt (pictured holding the post) came to Dallas in 1907, a nationwide legal battle between theatrical bookers and theatre owners prevented Bernhardt from legally performing in any theatre building, so her promoters erected a tent in which she performed legally. (Courtesy Jim Wheat.)

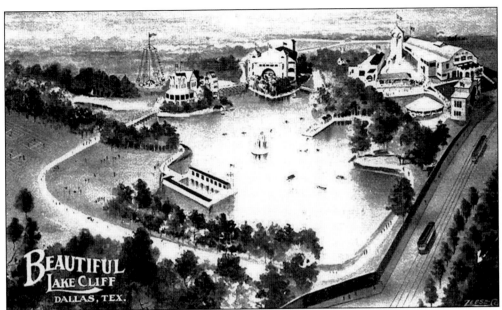

BEAUTIFUL
LAKE CLIFF
DALLAS, TEX.

LAKE CLIFF PARK. Designed to be a summer resort with something for everyone, Lake Cliff Park was the brainchild of Charles Mangold, a Dallas liquor magnate. Completed in 1907, Lake Cliff went unchallenged as the largest, most spectacular amusement resort in Texas. The park included rides, sports, a restaurant, gardens, bands and orchestras, 10,000 lights, and a fireworks show each night. It also featured a small movie theatre and a 1,900-seat casino theatre with resident stock company, which presented numerous high-quality productions each season. However, in 1914, it all ended due to high operation costs and other unforeseen events, including a flood, which prompted Mangold to sell the resort and its land to the City of Dallas. The casino was moved and used as a movie studio, but a fire destroyed it in the 1920s. (Both, courtesy Texas/Dallas Archives, Dallas Public Library.)

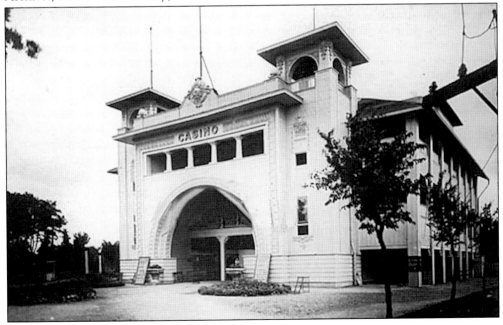

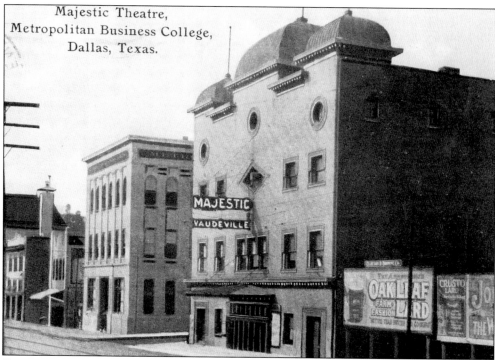

Majestic Theatre, Metropolitan Business College, Dallas, Texas.

COMMERCE AND ST. PAUL STREETS, NORTHEAST CORNER. Karl Hoblitzelle celebrated his 26th birthday just eight days before opening his Majestic Theatre in Dallas on October 30, 1905. The young St. Louis man was forced to quit school to help his struggling parents and 12 siblings. After working for the World's Fair, Hoblitzelle founded the Interstate Amusement Company, building a chain of southern theatres. After teaming with the Keith and Orpheum Circuits, the Interstate Circuit was created for southern states. Vaudeville was unknown to Dallas and the South until Interstate imported it from the Northeast. The 1,200-seat Dallas Majestic was of Oriental motif: pagodas topped the building's illuminated exterior; the lobby included high marble wainscoting and mosaic floors; and the ornate auditorium was done in reds, greens, and browns, with generous use of velvet and gold cabinetwork. The theatre burned in December 1917, but the show went on. (Above, author's collection; below, courtesy Mary McCord/Edyth Renshaw Collection on the Performing Arts, Jerry Bywaters Special Collections, Hamon Arts Library, Southern Methodist University.)

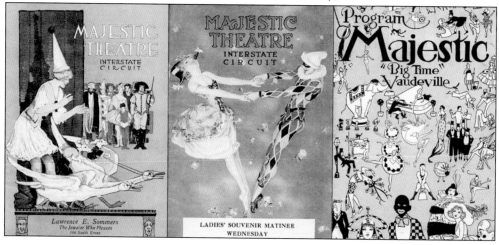

THE SECOND MAJESTIC.
Within hours after the fire, Interstate temporarily leased the Dallas Opera House so the next Majestic show could go on. Movies and vaudeville were all the rage; opera house programs were becoming passé and barely profitable. The opera house organization decided to cancel its future bookings and sign a long-term lease with Interstate. And so the Dallas Opera House passed into history, and the Majestic had a new home. (Courtesy Texas/Dallas Archives, Dallas Public Library.)

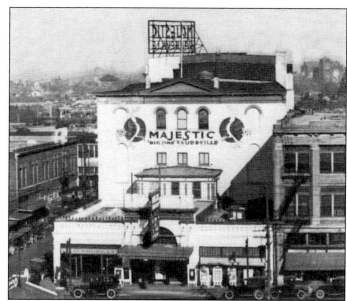

1500 BLOCK OF MAIN STREET, LOOKING WEST. The Majestic's success bred imitators. By 1907, several dinky, small-time vaudeville (and movie) houses started opening along Main Street: the Dalton (later the Favorite) at 1511, the Penny Arcade at 1519, the Colonial (later the Happy Hour) at 1520, the Empire (later the Orpheum, then the Feature) at 1521, the Nickelodeon at 1607, the Grand (later the Roseland) at 1613, the Beauty (later the Best) at 1615, and the Lyric at 1620. Closing in 1924, the Best was Main Street's last theatre. (Courtesy Texas/Dallas Archives, Dallas Public Library.)

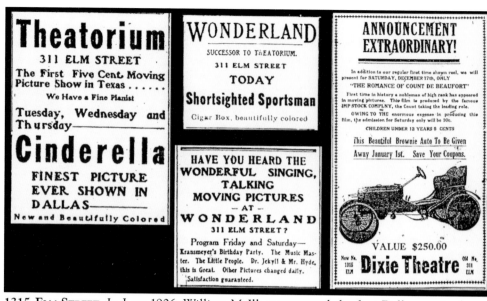

Theatorium

311 ELM STREET

The First Five Cent Moving
Picture Show in Texas

We Have a Fine Pianist

Tuesday, Wednesday and
Thursday—

Cinderella

FINEST PICTURE
EVER SHOWN IN
DALLAS—

New and Beautifully Colored

WONDERLAND

SUCCESSOR TO THEATORIUM.

311 ELM STREET

TODAY

Shortsighted Sportsman

Cigar Box, beautifully colored

HAVE YOU HEARD THE
WONDERFUL SINGING,
TALKING
MOVING PICTURES
— AT —
WONDERLAND
311 ELM STREET?

Program Friday and Saturday—
Kransmeyer's Birthday Party. The Music Master. The Little People. Dr. Jekyll & Mr. Hyde, this is Great. Other Pictures changed daily. Satisfaction guaranteed.

**ANNOUNCEMENT
EXTRAORDINARY!**

In addition to our regular first time shown reel, we will present for SATURDAY, DECEMBER 17th, ONLY
"THE ROMANCE OF COUNT DE BEAUFORT"
First time in history a nobleman of high rank has appeared in moving pictures. This film is produced by the famous IMP STOCK COMPLNY, the Count taking the leading role.
OWING TO THE enormous expense in producing this film, the admission for Saturday only will be 10c.

CHILDREN UNDER 12 YEARS 5 CENTS

This Beautiful Brownie Auto To Be Given
Away January 1st. Save Your Coupons.

VALUE $250.00

Dixie Theatre
New No. 1315 ELM Old No. 311 ELM

1315 ELM STREET. In June 1906, William McIlheran opened the first Dallas movie theatre, the 350-seat Theatorium, in an Elm Street storefront. Henry Putz had previously shown films in a hot storeroom above the Bumpas and Kirby drugstore, and the Dallas Opera House and the Majestic had shown movies, but only as dispensable novelties to supplement the "real" show onstage. However, the Theatorium was the first building used exclusively for exhibiting films, and it was a huge success. Other storefronts were quickly converted into "picture parlors." Competition became fierce: prizes were given to repeat customers, and gimmicks were devised. In 1907, "color film" meant blue- or red-tinted black-and-white film, and "talking movies" translated to a guy behind the screen shouting with a megaphone, sloppily synchronized with the flickering illumination of a screen actor's moving mouth. In 1907, the Theatorium was renamed the Wonderland, and then the Dixie. It operated until 1928 and has been demolished. (Both, courtesy Mary McCord/Edyth Renshaw Collection on the Performing Arts, Jerry Bywaters Special Collections, Hamon Arts Library, Southern Methodist University.)

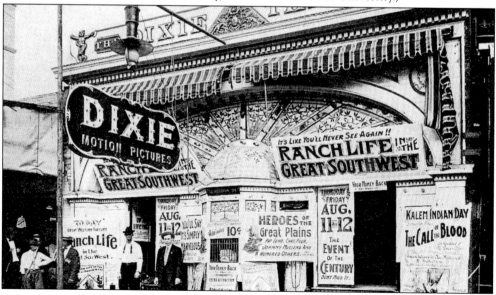

Two

DOWNTOWN

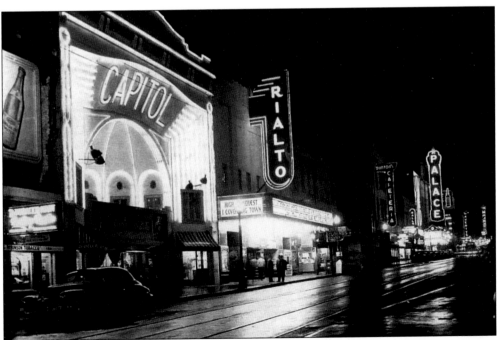

1500 BLOCK OF ELM STREET, LOOKING EAST, 1947. At one time, Elm Street had more theatres than any other street in America, aside from New York City's Broadway. The lights were so bright one could easily read a newspaper on the sidewalk at night, as many older Dallasites recall. It is all gone now, with the exception of the Majestic. (Courtesy Texas/Dallas Archives, Dallas Public Library.)

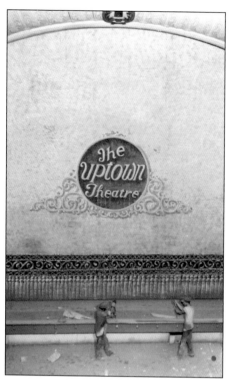

316–320 North St. Paul Street. Originally opened on December 25, 1923, as a home of dramatic stock, the 1,100-seat Circle Theatre was described as intimate and beautiful, without being ostentatious. Brass fixtures, such as banisters and fountains, were set against delicately etched stone. Edith Luckett, mother of Nancy Reagan, was a lead actress in the Circle Players Stock Company. In 1926, there was an outcry from moralists against the Circle following its production of the controversial play *White Cargo*. In 1928, the theatre sought to escape its tarnished image by changing its name to the Showhouse Theatre; it closed in January 1932. On April 1, 1934, it reopened as the Uptown Theatre, unsuccessfully presenting dramatic stock before switching to films in 1935. It was extensively remodeled and reopened as the Joy Theatre (not to be confused with the Joy on Elm Street) on September 1, 1943. A third-run film house popular through the war years, the Joy finally closed in 1947. Republic Bank acquired the theatre for storage use from the early 1950s through 1977, when it was demolished. (Both, courtesy Texas/Dallas Archives, Dallas Public Library.)

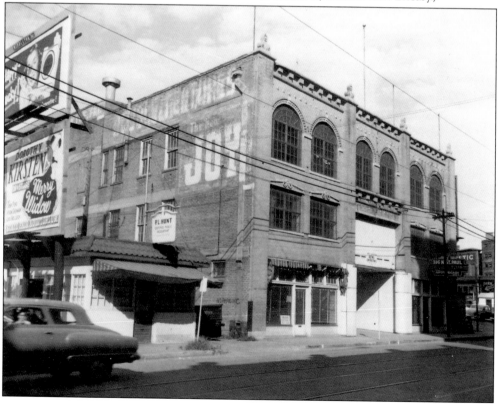

214 North Akard Street. Located directly behind the Queen Theatre, the 500-seat Happyland Theatre opened on March 22, 1922, as a venue for "musical tabloid" (a cross between vaudeville and burlesque). On November 25, 1923, it reopened as the Lyric Theatre, featuring musical comedy and vaudeville. In 1932, it again changed its name to the Rio Theatre, featuring burlesque. It closed in 1933 and has been demolished. (Courtesy Texas/Dallas Archives, Dallas Public Library.)

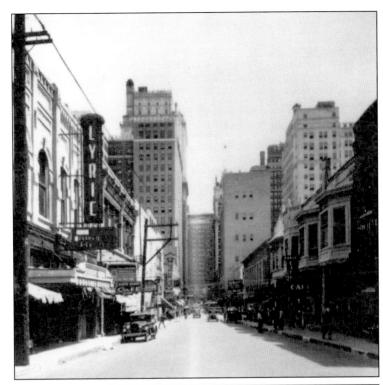

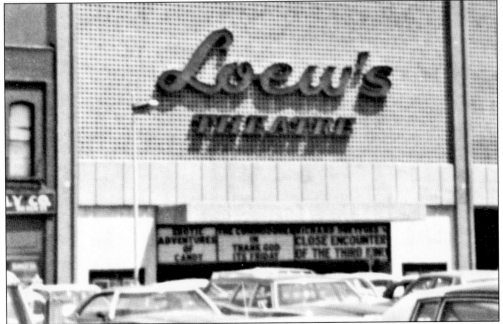

1015 Elm Street. It had been decades since the last theatre was built downtown when the 1,000-seat Loew's Studio Theatre opened on June 6, 1969, with *Those Daring Young Men in Their Jaunty Jalopies*. In 1975, it was remodeled as a triplex theatre, and in 1981, after a change in ownership, it switched briefly to Spanish-language films and was renamed the Cine Centro. Around 1983, the building was gutted for use as a parking garage. (Photograph by author, 1977.)

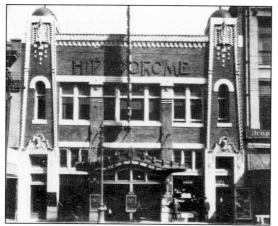

1209–1211 Elm Street. The fireproof Hippodrome Theatre opened on March 1, 1913. Designed by Lang & Witchell, the Hippodrome featured a marble lobby and a 1,200-seat auditorium with an Egyptian Revival motif. In 1933, it became the Joy Theatre, a notorious burlesque house, and in 1941, it became the Wade Theatre, another burlesque house. In 1947, it was renamed the Strand Theatre, which showed second-run "B" movies. It closed around 1957 and was demolished in 1960. (Courtesy Texas/Dallas Archives, Dallas Public Library.)

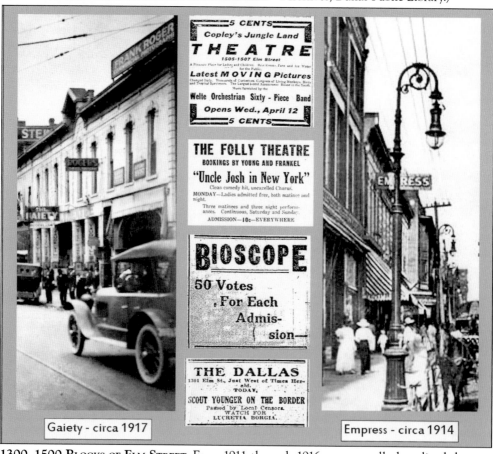

Gaiety - circa 1917

Empress - circa 1914

1300–1500 BLOCKS OF ELM STREET. From 1911 through 1916, many small, short-lived theatres opened on these three blocks: the Dallas Theatre (1913–1914) at 1301; the Bioscope (1911–1916) at 1310, later becoming the Strand (1916–1927); the Empress (1913–1916) at 1409; the Candy (1913–1916) at 1411 and the Palace (1913–1915) at 1413, which both merged to make the Gaiety (1916–1921); the Princess (1911–1921) at 1415; the Garrick (1915–1923) at 1504; the Jungleland (1908–1911) at 1505, later becoming the Folly (1911–1914), then the Newport (1915–1916); and the Rex (1916–1923) at 1510. (Courtesy Texas/Dallas Archives, Dallas Public Library.)

1400 BLOCK OF ELM STREET. By 1921, almost all the storefront theatres had vanished, unable to compete with the larger, fancier theatres opening along Elm Street. In 1921, the Princess was razed for the Gus Roos Co. clothing shop, and the Gaiety came down for the Fox Theatre, opened as a clean little second-run film house (discussed further in Chapter Four). (Courtesy Texas/Dallas Archives, Dallas Public Library.)

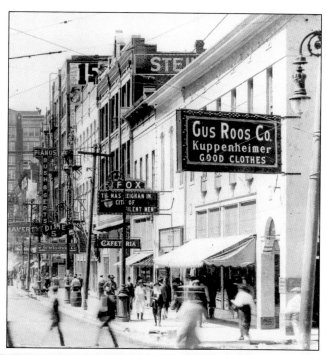

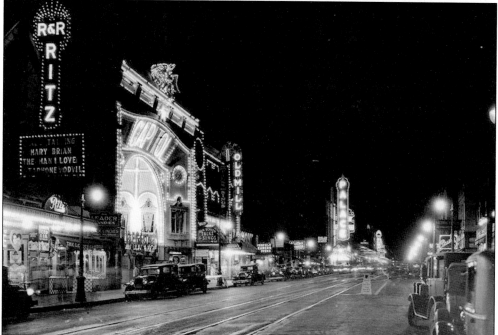

1517 ELM STREET. The Garden Theatre opened on October 13, 1912, as a 1,000-seat vaudeville house. In 1915, it became the Jefferson, a venue for the Loew's Vaudeville Circuit and, later, for the Pantages Circuit. In December 1925, it became the Pantages, presenting vaudeville and films. It became the Ritz in 1928, showing exclusively second-run films. After extensive remodeling, it reopened in December 1931 as the high–Art Deco Mirror Theatre. A fire eventually destroyed it on August 4, 1941. (Author's collection.)

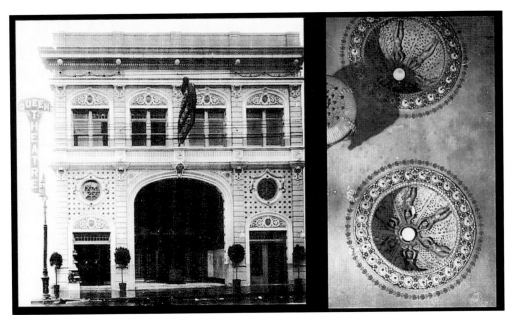

1501 ELM STREET. The Queen Theatre opened on January 23, 1913, and was said to be the finest motion picture theatre in the South and the most beautifully decorated. The 900-seat theatre included a grand pipe organ and a five-piece orchestra. Dozens of plaster sculptures of nudes decorated the auditorium, along with bas-relief wall panels depicting various queens throughout history. Flickerless projectors were used, and movies were projected on a state-of-the-art glass-and-silver screen. Thousands of Dallasites appeared at the opening-day shows, presented each hour from 11:00 a.m. through 11:00 p.m. (Both, courtesy Dallas Historical Society Photograph Archives.)

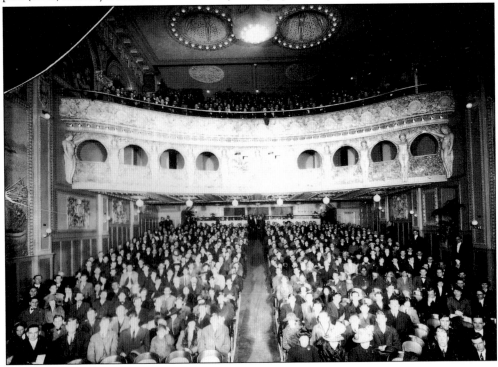

1501 ELM STREET. The Queen maintained its position as one of the top cinemas in Dallas throughout the 1910s, but remodeling following a 1917 fire eliminated much of the ornate decoration in the auditorium. In the early 1920s, when more modern, luxurious movie palaces were built farther down Elm Street, the Queen's crown quickly tarnished. Second-run and second-rate films became typical fare, and less desirable customers became frequent patrons. Unruly children, crying babies, pickpockets, and mashers made for an unpleasant movie experience, to say the least. The Queen renamed itself the Leo Theatre in September 1948 and fluctuated between third-run "B" westerns and exploitation/burlesque films. It closed in 1953 and was demolished in 1955. (Above, courtesy Dallas Historical Society Photo Archives; below, courtesy Texas/Dallas Archives, Dallas Public Library.)

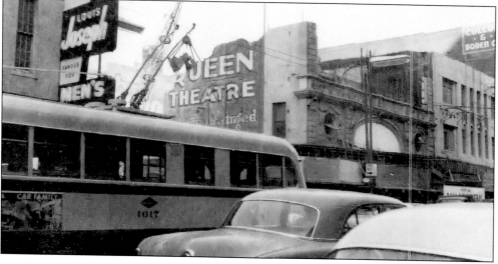

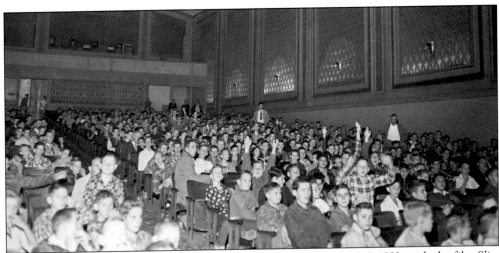

1521–1523 ELM STREET. The Capitol Theatre opened on December 16, 1922, with the film *Slim Shoulders*, starring Irene Castle. The 1,200-seat theatre was built to be a quality discount cinema and included a $20,000 Barton organ. A multicolored fountain decorated the lobby; the white exterior, outlined in blue neon, was designed to resemble a capitol dome. There was no balcony, which owners claimed improved ventilation and ease of exiting. The Capitol occasionally showed first-run movies and even hosted several premieres, the most notable of which was the southern premiere of *The Hunchback of Notre Dame*, starring Lon Chaney, in 1923. From the 1930s through the early 1950s, the Capitol was popular with children for its low-budget Westerns and monster movies. It steadily declined in condition and quality before finally closing in 1956. It was demolished in January 1959. (Both, courtesy Texas/Dallas Archives, Dallas Public Library.)

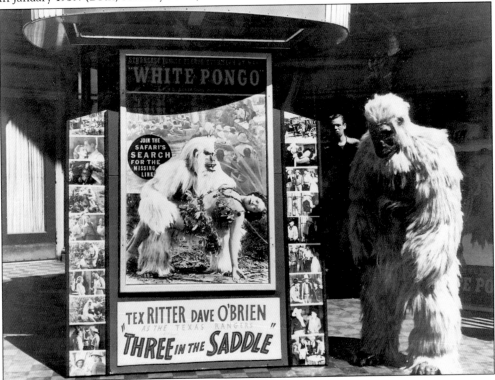

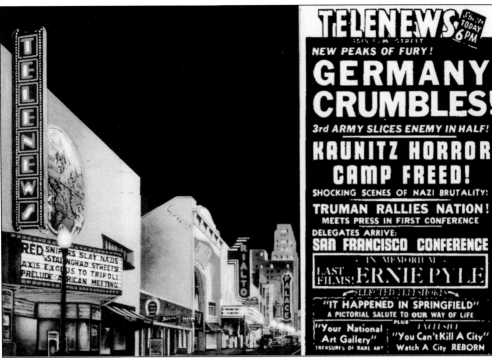

1515 ELM STREET. Opened on November 21, 1941, the Telenews Theatre was built partly on the site of the recently burned Mirror Theatre. Modern and subdued, the 640-seat Telenews contained Teletype machines in the lobby, and the second floor included a radio broadcasting studio and customer reading lounge stocked with newspapers and magazines. The exterior displayed a 16-foot-diameter bas-relief world map outlined with silver-leafed film and film reels. Part of the Telenews chain of newsreel-only theatres, the Dallas Telenews coincidentally opened less than three weeks before the attack on Pearl Harbor plunged America into World War II. The public hungered for news, and the Telenews thrived through the war years. Afterward, it tried programs of art and revival films, with only moderate success. On December 22, 1949, it changed its name to the Dallas Theatre (discussed further in Chapter Four). (Both, author's collection.)

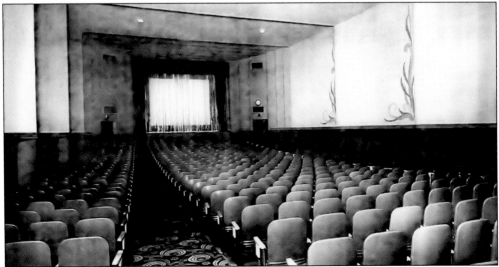

ADVERTISEMENTS. This collection of movie advertisements highlights many of the classic blockbusters that entertained downtown Dallas moviegoers, showing all the big-screen stars of the day, from

Charlie Chaplin to King Kong. It wasn't as convenient as plopping a DVD into the machine, but it was infinitely more fun, more memorable, and more human. (Author's collection.)

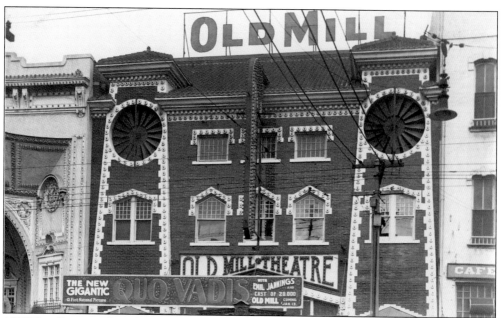

1525 ELM STREET. The 1,500-seat Old Mill Theatre opened on June 24, 1913, primarily for films. Designed by architect J.A. Walker to resemble an old Dutch mill, the Old Mill maintained a reputation for quality and remained successful until closing in May 1935. After being rebuilt from "wall to wall," the new Rialto Theatre opened on September 13, 1935, on the site of the Old Mill. Designed by Nena Claiborne in a sleek, Art-Deco style, the color scheme was described as "unabashed" and "shrewdly bizarre." The opening program consisted of *Annapolis Farewell*, a newsreel, and a Thelma Todd–Patsy Kelly comedy. A successful second-run house through the early 1950s (when its condition and program quality began to rapidly decline), the Rialto closed in early 1959 and was quickly demolished for a parking lot. (Both, courtesy Mary McCord/Edyth Renshaw Collection on the Performing Arts, Jerry Bywaters Special Collections, Hamon Arts Library, Southern Methodist University.)

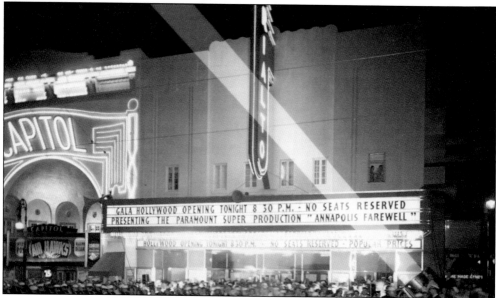

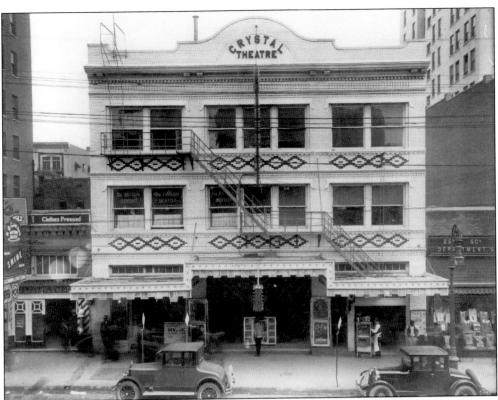

1608 Elm Street. The $100,000 Crystal Theatre opened on September 25, 1913, with *A Sister to Carmen*, starring Helen Gardner. Exclusively for films, the Crystal was built on the site of a smaller storefront theatre, also called the Crystal, and was one of only four theatres ever located on the south side of Elm Street. The 600-seat auditorium was decorated with Japanese art, lanterns, and the words "a hundred presents, a thousand welcomes" written in Japanese characters on several wall panels. The lobby featured mirrored walls topped with a fresco depicting a Japanese love story. The Crystal operated as a second-run house with varying success through the 1920s. McCrory's Stores bought out its lease, and it closed on September 30, 1928. It was demolished soon after and eventually replaced with a W.T. Grant's store. (Above, courtesy Texas/Dallas Archives, Dallas Public Library; right, author's collection).

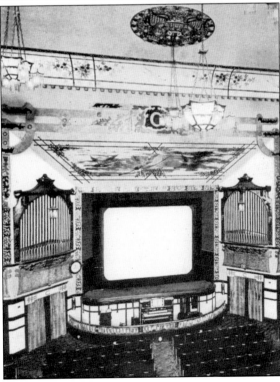

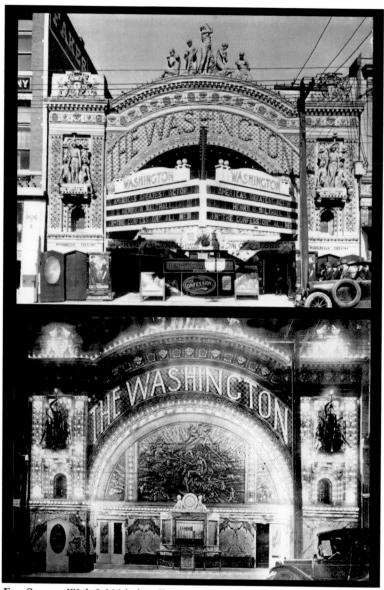

1613–1615 Elm Street. With 2,000 lights illuminating its facade, the 600-seat Washington Theatre was the first of the fancy Dallas film houses when it opened on November 28, 1912. Compared to the storefront theatres, the Washington's interior was more comfortable and modestly more attractive. However, its extravagant exterior is what set it apart. Thousands of movie theatres were opening in the United States in 1912, so theatre owners wanted a competitive edge. To that end, two Illinois companies offered catalogs of garish statuary and ostentatious pressed-metal facades created especially for storefronts and smaller theatres—all solely to catch the eye of those seeking the magical and the romantic, and to transform mere storefronts into the portals of enchanted worlds to which many seek to escape mundane existence. But, by 1921, authentic marble palaces had been built on Elm Street, dwarfing the Washington in their shadows. Huge pieces of its once impressive array of decorative statuary crumbled, smashing to the sidewalk and, in turn, requiring the removal of remaining figures for safety. The Washington closed in June 1927 and was demolished in 1932. (Courtesy Texas/Dallas Archives, Dallas Public Library.)

1623–1625 ELM STREET. When the Palace Theatre opened on June 11, 1921, it was described as the most beautiful theatre in America by some of the most important people in show business. Built by Southern Amusement Company for more than $1 million (equivalent to $90 million today), the Palace was the largest, most spacious Dallas theatre, seating 3,000 comfortably, and was designed with a domed ceiling and a vast, multitiered curve of seats sweeping across the auditorium. The gracefully pitched house floor measured 120 feet by 150 feet, and the balcony was suspended without the view-obstructing posts common in other theatres. Chicago designer A. Vollmer, who also designed Broadway's famed Capitol Theatre, employed a color scheme of creams, browns, blues, and golds, together with suffused lighting, scagliola columns and balustrades, extensive use of marble, and tapestries of silk and velour hued in cobalt blue and old gold. (Both, courtesy Texas/Dallas Archives, Dallas Public Library.)

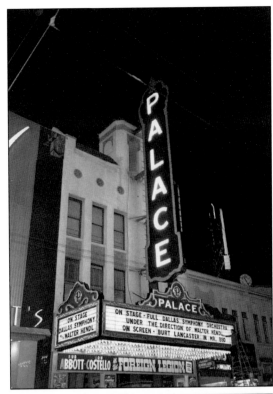

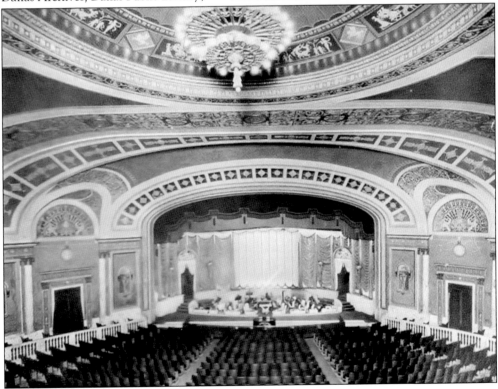

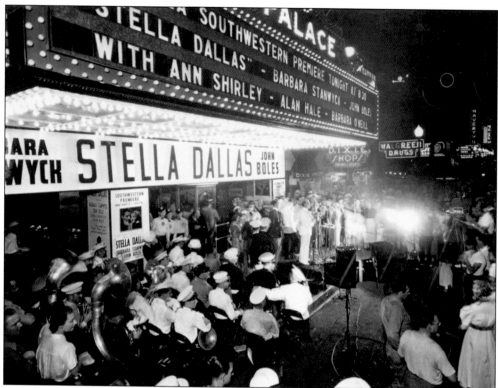

1623–1625 ELM STREET, 1937. It is fitting that the Palace opened with Paramount's *Sentimental Tommy*, because it became known as the "sentimental theatre" over the years due to the frequent romances and tearjerkers it featured. On December 3, 1970, Anthony Quinn's *Flap* was the Palace's final film, and though a comedy, tears far exceeded laughs that evening on Elm Street. (Courtesy Mary McCord/Edyth Renshaw Collection on the Performing Arts, Jerry Bywaters Special Collections, Hamon Arts Library, Southern Methodist University.)

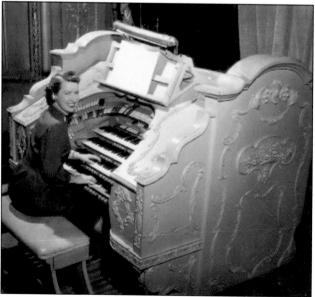

THE PALACE WURLITZER. Seeing and hearing the Palace Wurlitzer Publix No. 1 was unforgettable. Installed on a hydraulic platform, the massive instrument rose dramatically from beneath the stage while bellowing a medley of popular tunes between each movie. Organist Weldon Flanagan played for many years up through closing night. Local legend Inez "Miss Inez" Teddlie (pictured here) played the Palace organ for a weekly radio show. The majority of the Palace Wurlitzer's parts are now used at the California Theatre in San Jose, California. (Courtesy Jim Wheat.)

1623–1625 ELM STREET, 1957–1971. For more than 60 years, Interstate Amusement Company successfully combined smart business practices with sincere civic leadership. When the Disney classic *Old Yeller* opened at the Palace, Interstate teamed with the SPCA and city health department to educate the public about rabies and responsible pet ownership while also promoting the film. When Interstate's lease neared expiration in 1970, the private owners of the Palace accepted a purchase offer from developers rather than renew the lease. Within a few weeks of closing, the Palace was quickly demolished (shown below), only to sit as a parking lot for more than a decade. In 1982, a 50-story office tower was built, which sits almost half-vacant today. (Both, courtesy Texas/Dallas Archives, Dallas Public Library.)

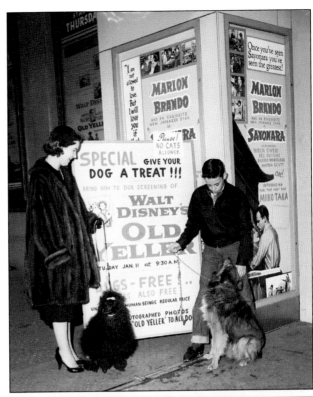

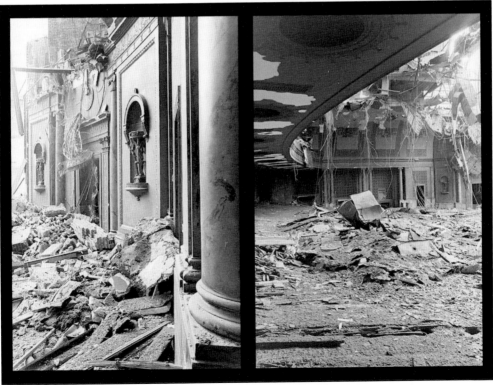

1907 ELM STREET. The 1,320-seat Tower Theatre opened on February 19, 1937, with *Rainbow on the River*, starring Bobby Breen. The lobby, decorated with soft-colored mirrors, was more like a series of expanding foyers leading to the auditorium, which faced the Pacific Avenue wall. A large built-in aquarium in the lobby was another unusual feature, as was the neon lighting beneath the center handrail of the stairway. The auditorium was designed mostly in salmon, blue, and beige and included leather-upholstered seats. The Tower was one of the last theatres ever built downtown. Around 1950, the auditorium was enlarged, and the decor was "updated" to the banana-leaf motif popular in 1950s-era theatres (as seen in the gorilla photograph below). The Tower was often used for road shows and extended-run films, which sometimes played for months. Closing on August 14, 1971, it was gutted around 1981. (Both, courtesy Texas/Dallas Archives, Dallas Public Library.)

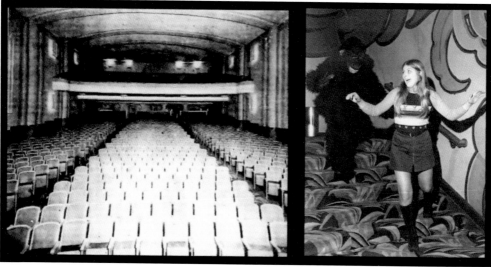

1911–1915 ELM STREET. Originally planned as the Melba, named for the owner's wife, the 2,500-seat Hope Theatre opened on April 26, 1922, with *Cops*, the classic Buster Keaton short, followed by the feature *Stardust*, starring Houston-born Hope Hampton, for whom the theatre was named at the insistence of J.D. Williams, who signed a 25-year lease during construction. Hope Hampton enjoyed brief success in silent films and, later, opera with the support of a wealthy husband, leading to speculation that "Susan Alexander," the mistress character in *Citizen Kane*, was partly modeled on Hampton. Four months after opening, the Hope closed when J.D. Williams encountered financial problems and surrendered the lease. It reopened on October 8, 1922, as the Melba Theatre. (Right, courtesy Mary McCord/Edyth Renshaw Collection on the Performing Arts, Jerry Bywaters Special Collections, Hamon Arts Library, Southern Methodist University; below, courtesy Texas/Dallas Archives, Dallas Public Library.)

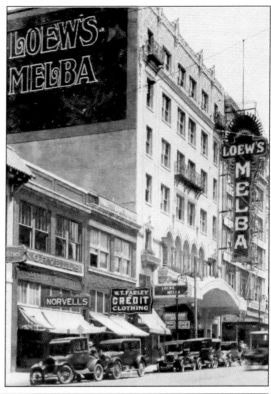

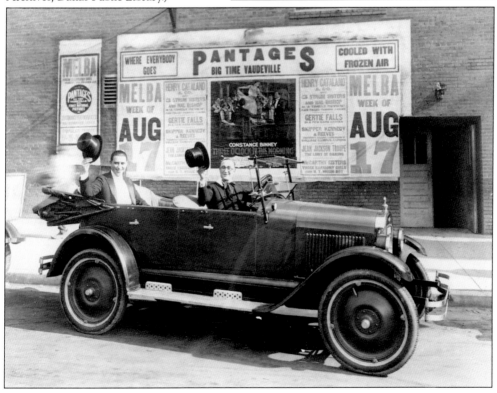

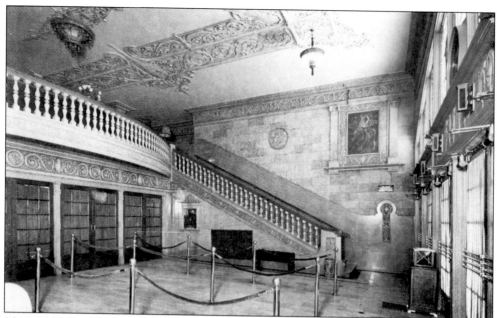

1911–1915 ELM STREET, INTERIOR. Designed in the Spanish Renaissance style with special attention given to its intricate Moorish elements, the building's foyer contained no obstructive pillars or columns to interrupt the impressive breadth of its lobby, done entirely of marble, with ornate stairways symmetrically framing each end. Varied shades of yellows, greens, and browns blended harmoniously with deep-orange velvet stage draperies, heavily fringed in antique gold. The auditorium's huge domed ceiling was extraordinarily high and richly decorated with hundreds of colorful details. The exterior's vertical sign measured more than 40 feet high, with 6-foot letters. (Both, courtesy Texas/Dallas Archives, Dallas Public Library.)

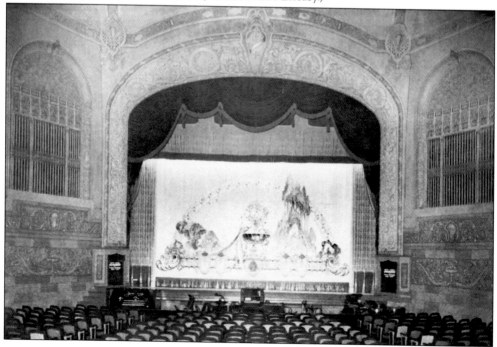

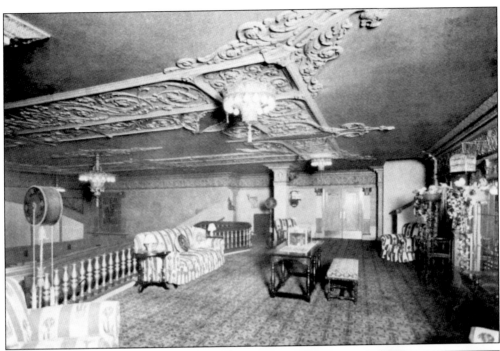

1911–1915 ELM STREET, BALCONY FOYER AND BOX OFFICE. Local theatre operator P.G. Cameron acquired the Melba around 1924 to feature films and Pantages vaudeville acts. The below photograph on page 39 shows two vaudevillians from the Pantages Circuit behind the Melba on Pacific Avenue. Around 1926, Loew's Theatres took over control of the Melba as a Dallas venue for the Loew's Vaudeville Circuit and MGM films until about 1928, when it was sold to Southern Enterprises. It was absorbed into the Interstate chain in the mid-1930s. (Both, courtesy Texas/Dallas Archives, Dallas Public Library.)

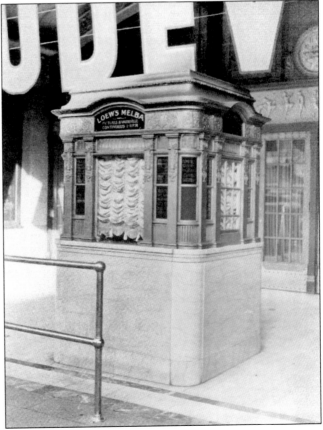

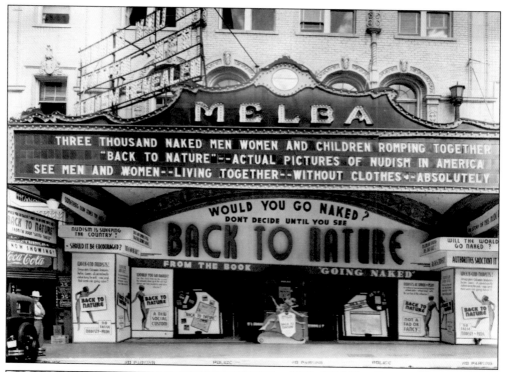

THREE THOUSAND NAKED MEN WOMEN AND CHILDREN ROMPING TOGETHER
"BACK TO NATURE"--ACTUAL PICTURES OF NUDISM IN AMERICA
SEE MEN AND WOMEN--LIVING TOGETHER--WITHOUT CLOTHES--ABSOLUTELY

WOULD YOU GO NAKED?
DONT DECIDE UNTIL YOU SEE
BACK TO NATURE
FROM THE BOOK "GOING NAKED"

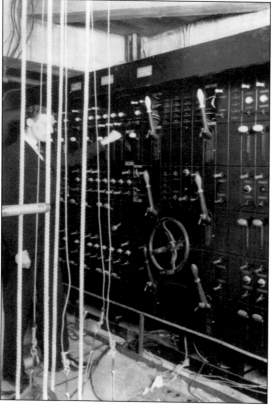

1911–1915 ELM STREET, MARQUEE AND BACKSTAGE. The above photograph, taken on September 16, 1933, at the height of the Great Depression, shows the Melba's titillating reopening marquee, after a four-month closure due to insufficient ticket sales. The film showed no male frontal nudity, but some bare breasts were displayed in an almost clinical (and far from erotic) documentary about nudist colonies. Within a couple of years, the theatre was back on its feet. For the production of live theatre, the Melba was technically superior to any Dallas theatre, and from the mid-1930s through early 1950s, it was used not only for films but also for hundreds of road company plays, featuring a who's who of stage and film actors, such as Tallulah Bankhead, Ethel Barrymore, Katherine Hepburn, Mae West, Lunt and Fontanne, et al. Its state-of-the-art light board is shown at left. In 1953, the Melba was retrofitted for Cinerama technology, which essentially consumed the stage with its immovable super-wide screen. (Both, courtesy Texas/Dallas Archives, Dallas Public Library.)

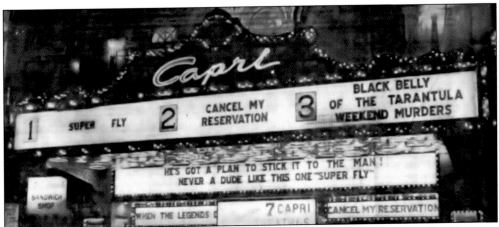

1911–1915 ELM STREET, FRONT AND BACK MARQUEES. In 1953, under the terms of an antitrust judgment, Interstate was required to relinquish control of several theatres, including one first-run house in downtown Dallas; the Melba was chosen reluctantly. The Cinerama Corporation of Texas then acquired it as its first Texas venue. Cinerama's popularity fizzled by 1958, and the massive screen was removed. On Christmas Day 1959, it was renamed the Capri Theatre, and the McClendon chain soon took it over, remodeling in 1970 to make two small theatres in the balcony, two in the basement, and two in the adjacent building (formerly a furniture store). The orchestra level, proscenium, and stage remained a single theatre. The Capri 7 complex operated until 1976. The building was structurally sound, and the multiplex remodeling did little, if any, damage to the original auditorium. It could have been easily restored but, instead, was demolished in 1981—almost secretly, with no fanfare and little news coverage. (Above, courtesy of *Dallas Times Herald*; below, photograph by author, 1979.)

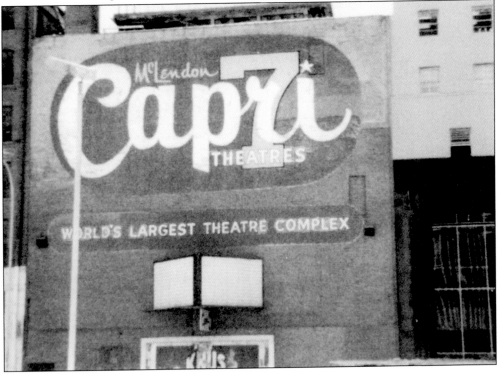

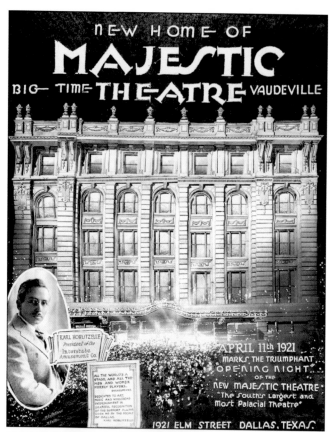

1921–1929 ELM STREET.
The third and final Majestic Theatre in Dallas opened on April 11, 1921, with a spectacular flourish. Karl Hoblitzelle told decorators to spare no expense to create the theatre of which he had dreamed since his youth. Below, the Majestic staff are on the stage c. 1925. Movie theatres provided a first job for thousands of young Texans, and a few made lifetime careers with Interstate Amusement Company or chains. While most went on to productive lives in other fields, a few became famous as actors, and a handful acquired less desirable notoriety—such as Clyde Barrow, who worked as an usher at the Palace Theatre on Elm Street before graduating to a legendary, yet brief, life of crime. (Left, author's collection, below; courtesy Texas/Dallas Archives, Dallas Public Library.)

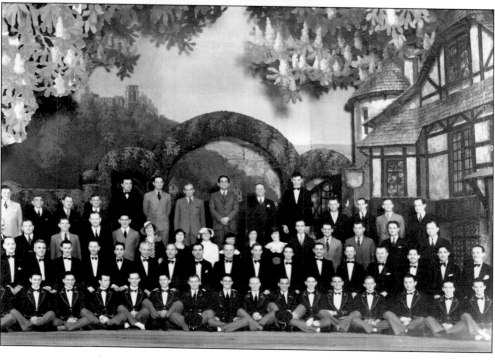

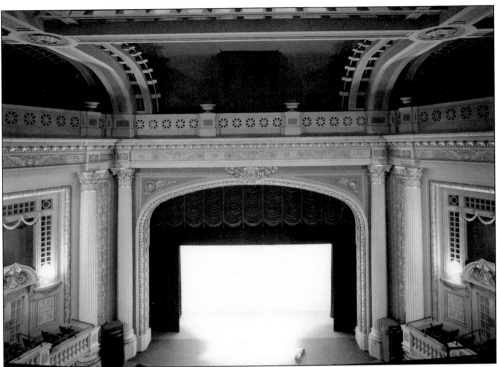

1921–1929 ELM STREET, INTERIOR. Noted theatre architect John Eberson designed the Majestic's 3,000-seat auditorium to replicate the Roman Forum, with a cobalt ceiling featuring animated clouds and stars. The lobby paid homage to the style of Louis XVI, including a hall of mirrors, à la Versailles, in the mezzanine foyer. (Both, courtesy Texas/Dallas Archives, Dallas Public Library.)

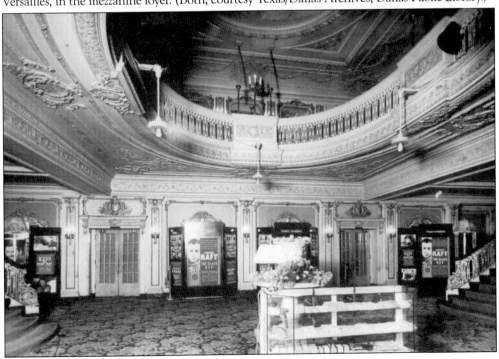

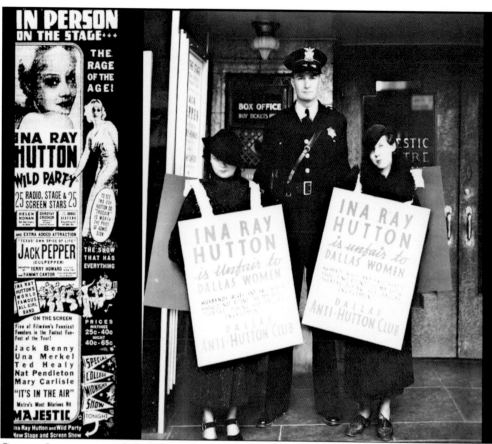

CRITICS. Interstate provided wholesome entertainment, but some were never satisfied. In 1909–1910, Christian fundamentalists and a like-minded sheriff waged war on theatres offering Sunday performances. Majestic employees were repeatedly arrested, but the theatres eventually prevailed in court. Pictured above are women protesting a slinky blonde female bandleader in 1935. Across the spectrum, the influential *Dallas Morning News* arts writer John Rosenfield (below with raised hand) preferred the title of "reviewer" to "critic." (Both, courtesy Texas/Dallas Archives, Dallas Public Library.)

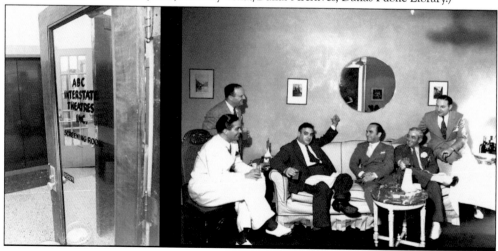

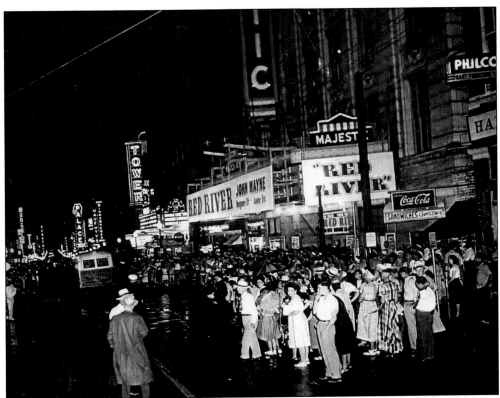

1921–1929 ELM STREET. The Majestic was sometimes called the "men's theatre" because of its frequent action films with male leads, while the Palace was called a "ladies' theatre" for its frequent romances with female leads. The Majestic closed on July 17, 1973 with the James Bond classic *Live and Let Die*. Below, paint is peeling on the Majestic's mezzanine ceiling five years after it closed. (Both, courtesy Texas/Dallas Archives, Dallas Public Library.)

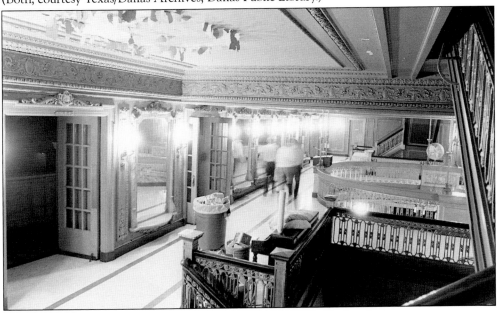

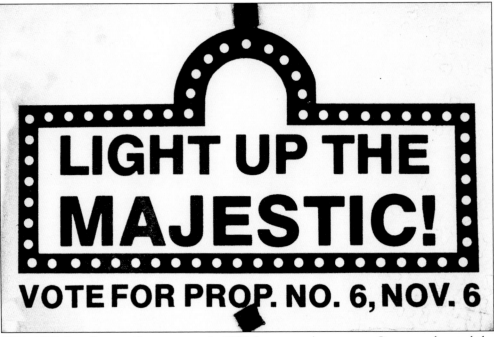

1921–1929 Elm Street, Renovation. In 1976, Interstate Amusement Company donated the Majestic to the City of Dallas. In 1979, after the Majestic sat for six years, a group of vigilant citizens, including this author, spearheaded a campaign to "Light Up the Majestic" with a bond proposal for $4 million to renovate and reopen the Dallas landmark. Above is a campaign yard sign. Below, is the 1983 grand reopening featuring Liza Minnelli in concert. (Above, author's collection; below, courtesy Texas/Dallas Archives, Dallas Public Library.)

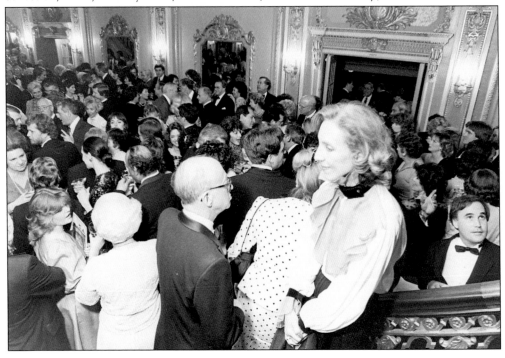

Three

SEGREGATION

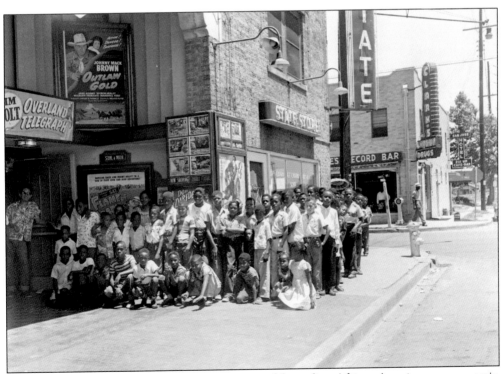

3217 THOMAS AVENUE. The *Dallas Express* was one of the earliest African American newspapers in Dallas. This c. 1951 photograph shows a party given by the *Express* for its delivery boys and girls at the State Theatre, located at Thomas Avenue and Hall Street. The State was the longest-operating African American theatre in Dallas. (Courtesy Texas/Dallas Archives, Dallas Public Library.)

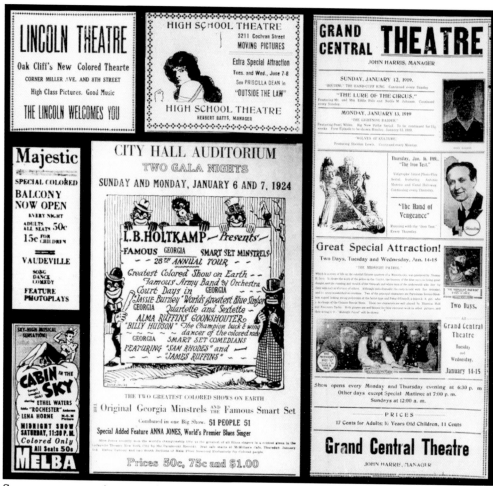

SEGREGATED AND AFRICAN AMERICAN–OWNED THEATRES. The earliest African American theatre in Dallas was the Black Elephant Variety Theatre at Young Street and Central Avenue (later relocated to Commerce Street) that operated during the 1880s and 1890s. The Grand Central Theatre dates back to the 1890s, and from 1914 through 1921, it operated as an African American movie house. The High School Theatre, a movie house across from the Dallas Colored High School, operated from 1915 until about 1920. The Lincoln Theatre, the first black cinema in Oak Cliff, operated from 1921 through 1924. The City Hall Auditorium (currently known as the Municipal Building on Harwood Street) hosted numerous productions during the 1920s and 1930s. The minstrel show advertised here was unique because African Americans, rather than whites, performed in blackface makeup. A large section of the auditorium was reserved for "colored" patrons. The Majestic opened a section of its second balcony to blacks in 1924. When the 1943 classic *Cabin in the Sky*, featuring an all–African American cast, opened for whites at the Majestic, a single "colored-only" showing was scheduled for one midnight at the Melba. (Author's collection.)

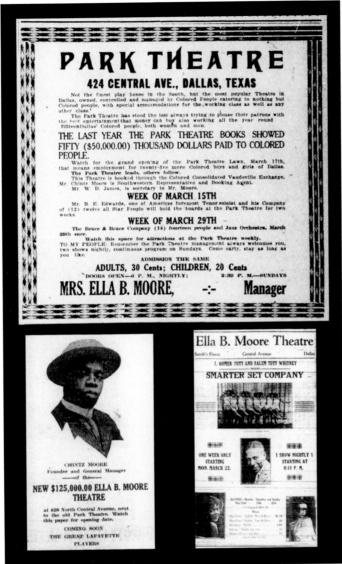

ELLA B. MOORE. Around 1916, Ella B. Moore and her husband, Chintz Moore, moved to Dallas from Philadelphia, where Ella was an actress. In Dallas, she became manager of the Park Theatre, a vaudeville house in "Deep Ellum." Mr. Moore raised $125,000 to build a theatre he would name for his wife. On October 20, 1924, the Ella B. Moore Theatre opened with Dallas mayor Louis Blaylock among the attendees. It included office space, a rooftop garden, 1,200 seats, and four boxes. The 35-foot stage was complemented by seven dressing rooms. An all-female usher staff was uniformed in Oriental costume. Later in the 1920s, the theatre presented late-night shows for white audiences, called "midnight rambles." In 1929, it was renamed the Central Theatre, but it is unclear exactly what prompted this change or what became of Ella and Chintz Moore. Evidence indicates a possible dispute between the Moores and the Theatre Owner's Booking Association (TOBA), which booked black performers on the "chitlin' circuit" of black theatres nationwide. The Moores left Dallas, possibly to Kansas City, Missouri. By 1933, both the Park and Ella B. Moore theatres forever closed and have since been demolished; no known photographs exist. (Author's collection.)

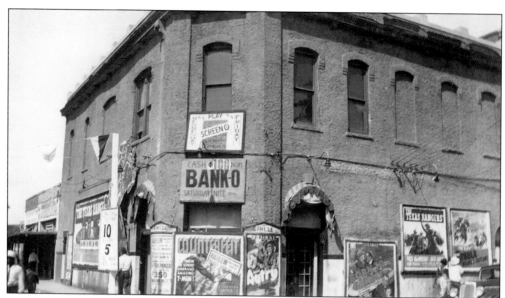

2401–2403 Elm Street. Converted from a saloon, the 350-seat Mammoth Theatre opened in 1914 as an African American cinema. In 1922, it became the Circle Theatre and operated through about 1940. Later used for automobile repair, it was demolished in the 1960s. The "SCREEN-O" and "BANK-O" signs above the entrance advertise keno-type games played in some theatres during the 1930s. (Courtesy Mary McCord/Edyth Renshaw Collection on the Performing Arts, Jerry Bywaters Special Collections, Hamon Arts Library, Southern Methodist University.)

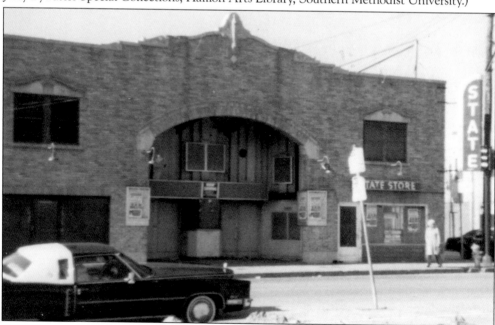

3217 Thomas Avenue, 1978. The 600-seat State Theatre opened on January 20, 1927, with *Finger Prints*, starring Louise Fazenda. Located in Freedman's Town, a historically African American area settled by ex-slaves in the 1860s, the State cost more than $75,000 to build (equivalent to about $800,000 today) and operated until 1967. It briefly reopened in the late 1960s as an adult theatre and was demolished in the early 1980s as a result of gentrification. (Photograph by author, 1978.)

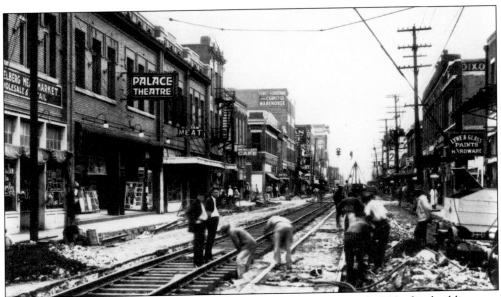

2407–2409 ELM STREET. Opened as the Standard Theatre around 1908, this building was renamed the Star around 1912. Remodeled in early 1920, it reopened as the 600-seat Palace Theatre on March 20. In 1933, after more extensive remodeling, it reopened as the Harlem Theatre, featuring movies, stage shows, and amateur nights, which were especially popular. But it soon became known as the most riotous place in Dallas. Fistfights, stabbings, shootings, and full-throttled sexual activities were commonplace. All races of gamblers, pimps, prostitutes, pushers, loan sharks, and pickpockets held court in or around the Harlem. However, customers returned because the shows were great. It was the most important Texas venue for unknown black talent to get started and discovered. Central Expressway construction decimated Deep Ellum, both physically and spiritually. The Harlem closed in 1962 and was demolished in 1968. (Both, courtesy Texas/Dallas Archives, Dallas Public Library.)

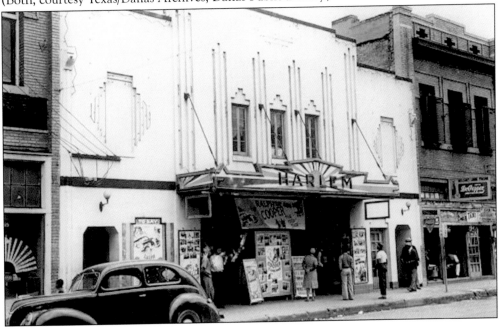

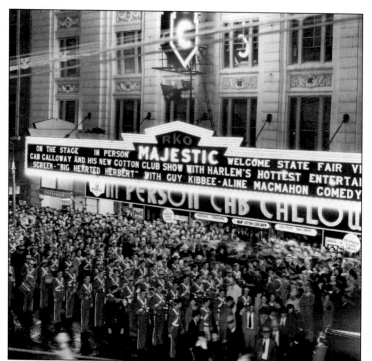

Big-Name Black Performers. Regardless of money or fame, segregation existed for all African Americans in the South. This was especially obvious when black stars arrived in Dallas to perform. Stars like Cab Calloway and Duke Ellington were limited to slum hotels, while whites in their entourage could enjoy top hotels and restaurants. (Courtesy Texas/Dallas Archives, Dallas Public Library.)

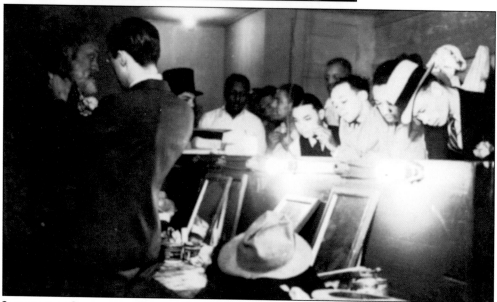

Integrated Community Theatre. In 1934, Oak Cliff was 92 percent white, which was amazing considering that, in 1934, the all-white Oak Cliff Little Theatre (OCLT) made the progressive and controversial decision to recruit an all-black cast (pictured here) and produce *Porgy*, a play by African American playwrights Dorothy and DuBose Heyward. The OCLT had already provoked right-wing hatred by previously using mixed-race casts. The production of *Porgy* was a huge success—held over for two weeks and setting a new OCLT ticket sales record. (Courtesy Mary McCord/Edyth Renshaw Collection on the Performing Arts, Jerry Bywaters Special Collections, Hamon Arts Library, Southern Methodist University.)

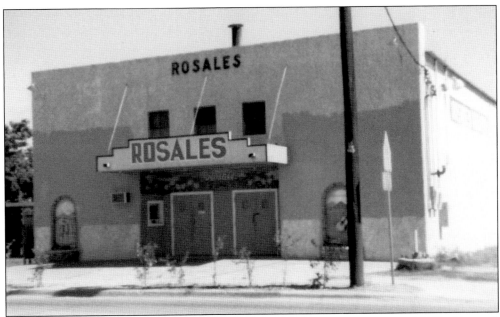

1846 SINGLETON BOULEVARD. Opened as the Carver Theatre sometime around 1948, this small 350-seat theatre was a popular spot with African Americans in West Dallas until its closure in 1960 as segregation was dying out. In 1967, it reopened as a Spanish-language cinema called the Rosales. The exterior was painted bright green with hand-painted floral and Mexican designs. The Rosales operated sporadically through 1980 and still stands as of 2013. (Photograph by author, 1978.)

5414 BEXAR STREET. The 600-seat Lincoln Theatre was one of the plusher all-black theatres when it opened in 1945. It was boycotted and picketed by African American unionists in the late 1940s for its refusal to employ union projectionists. After closing in 1960, the building was used for several purposes, including a brief stint as a Nation of Islam center in the 1990s. It sat vacant for a decade before its demolition around 2005. (Courtesy Randy A. Carlisle, RAC Photography.)

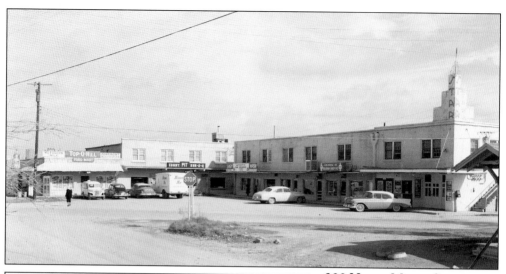

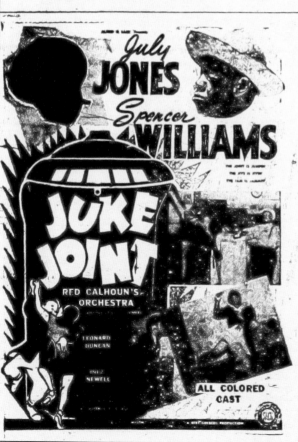

STAR THEATRE

Sun. — Mon. — Tues. — Wed.

July
JONES
Spencer
WILLIAMS

THE JOINT IS JUMPIN
THE JITTS IS HTIW
THE FUN IS FALMAKY

JUKE JOINT

RED CALHOUN'S ORCHESTRA

LEONARD DUNEAN

INEZ NEWELL

ALL COLORED CAST

300 North Moore Street. The 500-seat Star Theatre opened in 1943 as part of a small strip of shops at the northeast corner of North Moore and East Eighth Streets in the historically African American part of East Oak Cliff, now known as the Tenth Street District. In 1947, the Star hosted the world premiere of the now classic "race film" *Juke Joint*, directed by and starring Spencer Williams (widely known as "Andy" from television's *Amos and Andy*). Made in Dallas, the film was produced by a white man, Alfred Sack, of the Sack Amusement Company, a frequent producer and distributor of "race films" and also owner and operator of several white Dallas theatres. With segregation ending, the Star closed in 1959 and was converted into apartments. The Star and its adjoining shopping strip have since been demolished. (Top, courtesy Texas/Dallas Archives, Dallas Public Library; left, author's collection.)

4831 SPRING AVENUE. The tiny 275-seat Park Theatre opened sometime around 1946 and closed around 1962. Because it rarely advertised, determining exact dates of operation and program information has been impossible. Later in the 1960s through the 1970s, it was rented for private shows and parties before becoming a nightclub in the mid- to late 1970s. It was demolished in 2010. (Photographs by author, 1999.)

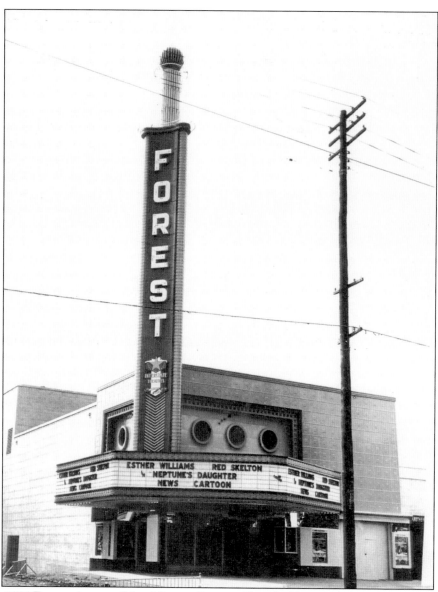

1914–1920 FOREST AVENUE (NOW MARTIN LUTHER KING JR. BOULEVARD). Originally intended for whites only, the 1,500-seat Forest Theatre opened on July 29, 1949, with *It Happens Every Spring*, starring Ray Milland. The opening included an outdoor block party with a square dance contest. Special opening festivities for children were held the following morning. The Forest featured a spacious lobby with a wide semicircular ramp gently sweeping up to the mezzanine in lieu of a traditional stairway. Murals of tropical birds and flowers adorned the walls, and the auditorium featured push-back seats and a "cry room." The prosperous 1950s witnessed blacks moving into the middle class, with many buying homes in the previously white area of South Dallas. On February 25, 1956, the Forest closed to whites, reopening days later as the new "Colored" Forest Theatre with a production of *Helen of Troy* and a short film with Nat King Cole. Closing in 1965 due to decreased sales, it has since been used for occasional special events. Recording artist Erykah Badu has used the theatre for various functions. (Courtesy Texas/Dallas Archives, Dallas Public Library.)

Four

ADULTS ONLY

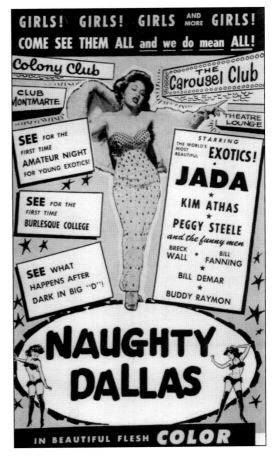

NAUGHTY DALLAS. In early 1963, Dallas filmmaker Larry Buchanan filmed what was to be another run-of-the-mill, low-budget burlesque film. Then, after the slayings of Pres. John F. Kennedy and his accused assassin, the world spotlight focused on Jack Ruby and the shadowy Dallas netherworld in which he dwelled—a world of burlesque stages and organized crime. Buchanan released the film in February 1964, smartly using the world's sudden interest in Dallas to his marketing advantage. (Author's collection.)

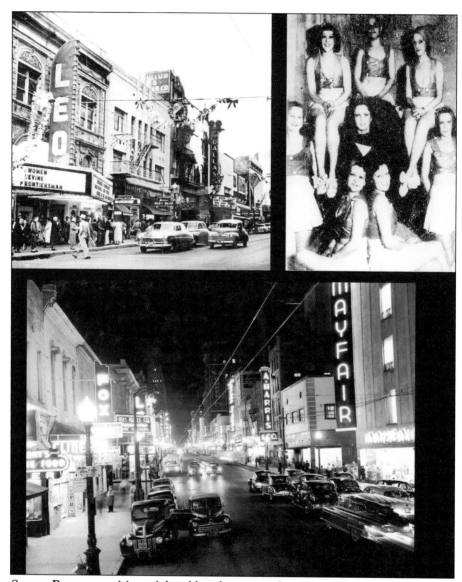

ELM STREET BURLESQUE. Most of the oldest downtown theatres could not compete against the newer, more luxurious downtown theatres and the increasing number of neighborhood theatres. In their fight to stay alive, they tried everything: "B" movies, exploitation films, rock-bottom prices, and the like. Many eventually turned to a proven moneymaker—sex—in the form of burlesque. The Lyric Theatre on Akard bordered on the risqué in the 1920s, but it was in the early 1930s, when the old Hippodrome became the Joy Theatre, that burlesque truly arrived. Beginning in 1933, religious activists, the PTA, and other censors repeatedly sought to close the Joy, with only minimal success. An angry audience loudly booed and catcalled three Dallas policemen who raided a midnight show, arresting the theatre owner (for maintaining a public nuisance) and two male comics (for indecent conduct). The chorus girls pictured here were summoned to court for contempt after the theatre violated an injunction prohibiting performances. The injunction was later dissolved and related charges dropped. The Joy operated through 1941, when it became the Wade Theatre, another burlesque house. (Top right, author's collection; all others, courtesy Texas/Dallas Archives, Dallas Public Library.)

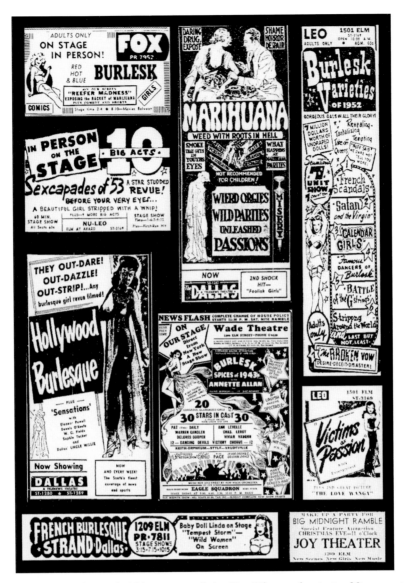

DALLAS DEMIMONDE. The mid-1930s witnessed the Fox Theatre begin its 30-year reign as the best-known second-rate burlesque house in Dallas. The all-newsreel Telenews, rendered obsolete after World War II, was renamed the Dallas Theatre, offering a bounty of salacious fare. Prostitutes (of both sexes) and dope peddlers made frequent appearances in these downtrodden downtown theatres. By the 1940s, the Queen was disparagingly called "the Queens" by those hearing tales of homosexual liaisons arranged (and sometimes completed) within its shadowy, pre-Stonewall balcony. In 1948, it became the Leo Theatre, but its reputation only calcified behind the gleaming new marquee. Likewise, the Fox Theatre certainly derived a significant portion of its gross receipts from those seeking only to use its unusually "popular" men's room. Throughout the 1950s, hundreds were nabbed on "perversion" or "sodomy" charges in vice stings at these theatres (and subsequently, hundreds of lives were destroyed by McCarthy-era lists of names, ages, home addresses, and arrest charges published in newspapers before the benefit of trial). However, this was a national trend and other, more reputedly "liberal" cities far exceeded Dallas in the frequency and brutality of such crackdowns. (Author's collection.)

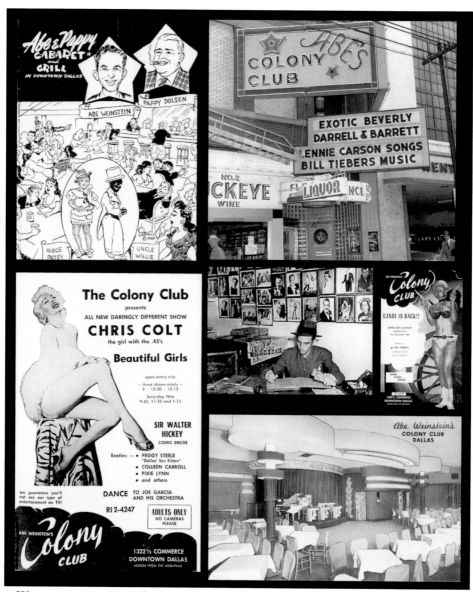

ABE WEINSTEIN AND 1322 1/2 COMMERCE STREET. Abe Weinstein (center image) was born in London in 1907 and immigrated to Dallas with his family in 1910. The family lived above its Deep Ellum secondhand store at 2312 Elm Street, where young Abe set up mechanical games out front to generate money. Dropping out of school in eighth grade to help the family, he worked at Volk's Department Store. In 1932, he opened the Triangle Club, a dime-a-dance hall, soon followed by the 25 Klub at 1925 1/2 Main Street, where everything cost a quarter and Cotton Club–style floor shows were offered for white audiences. In 1939, he partnered with fellow club owner Carl "Pappy" Dolsen and moved to a better location—the recently closed Ciro's Club at 1322 1/2 Commerce Street, across from the Adolphus Hotel. The new Abe and Pappy's Cabaret and Grill opened on March 3, 1940, with immediate success. In 1947, Dolsen sold out to Weinstein, the two parted amicably, and Abe and Pappy's became the legendary Abe's Colony Club. Before closing in 1972, the Colony was the city's classiest nightspot, showcasing some of America's top singers, comedians, variety acts, and only the most talented, tasteful striptease artists. (Author's collection.)

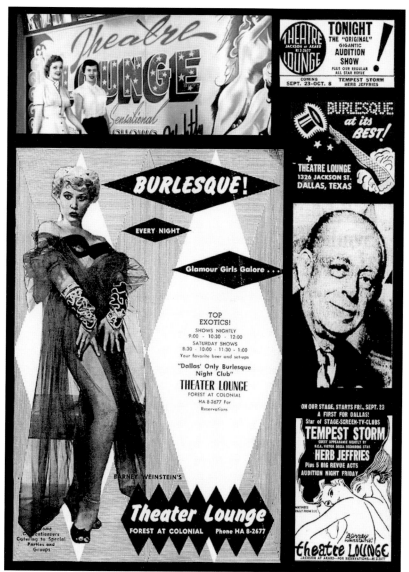

BARNEY WEINSTEIN AND 1326 JACKSON STREET. Barney Weinstein, like his younger brother Abe, was born in London in 1900. A pawnbroker until 1934, he then began to build a small chain of liquor stores. In 1949, Weinstein remodeled the old Colonial/Forest Theatre as a showroom, replacing theatre seats with tiers of tables to accommodate 300 guests and installing backlit murals, a color scheme of chartreuse and old rose, and an elevated, circular stage decorated with two spangled drama masks. Weinstein opened his new Theatre Lounge with an all-burlesque program, as well as the world's first "College for Strippers" at the club, which paid off for graduates. Nicki Joye, a Theatre Lounge college alumna, earned $4,000 monthly in the late 1950s (equivalent to about $30,000 today) at clubs nationwide. Weinstein's biggest discovery was a South Texas girl dubbed "Candy Barr," who became a star attraction in Dallas, Los Angeles, and Las Vegas, as well as the object of affection for West Coast crime boss Mickey Cohen. In 1959, the Theatre Lounge relocated to a larger space downtown at 1326 Jackson Street, near Akard Street, where it operated successfully before being destroyed by an overnight fire in 1970. It never reopened, and Barney Weinstein died the following year. (Author's collection.)

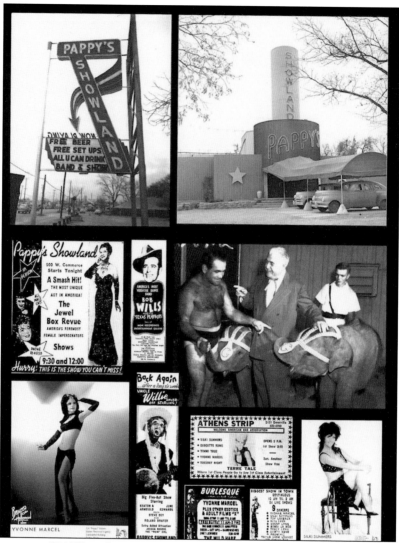

PAPPY DOLSEN AND 500 WEST COMMERCE. Born in Memphis, Dallas showman Carl "Pappy" Dolsen (shown in suit) hawked theatre candy at age 9, acted in traveling shows, served in World War I, and moved to Dallas, all by age 23. He opened a Ross Avenue speakeasy and Pappy's 66 Club on Commerce Street before his successful 1939 partnership in Abe and Pappy's Cabaret. Soon bored and dreaming bigger, Dolsen sold his interest to friend and partner Abe Weinstein. Pappy's Showland, a 1,300-seat open-air amphitheater at 500 West Commerce Street, opened in May 1946. A circus canopy provided winter enclosure, and Pappy's showcased top performers year-round until 1958, when the new Memorial Auditorium and newly dry Oak Cliff drained it of big names and beer. Dolsen parlayed his experience and contacts into a successful theatrical agency. Dolsen managed "Uncle" Willie Pratt, who went from a street urchin dancing for change to a world-traveled dancer and comic. Dolsen was referred to as the "King of the Strippers" for the dozens he represented, and was beloved by, with his showbiz pointers and his fatherly advice. Two such clients—Yvonne Marcel and Silki Summers—appeared often at the Colony Club, Theatre Lounge, and other local stages. Marcel went on to perform at top clubs nationwide. Both still live in Dallas and occasionally chat about the old days. (Top two images, courtesy Texas/Dallas Archives, Dallas Public Library; all others, author's collection.)

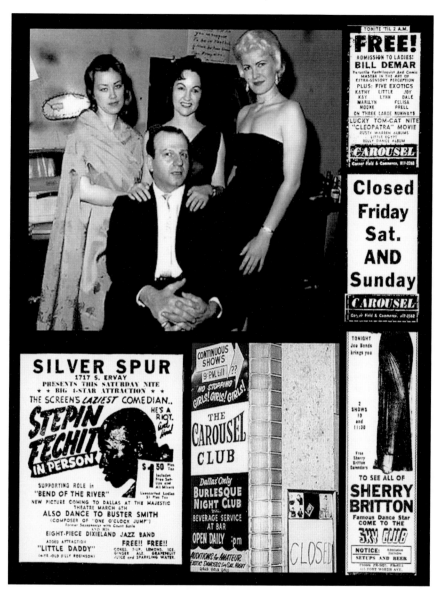

JACK RUBY (1911–1967). Jack Ruby was born in Chicago, where he worked odd jobs for the mob from childhood. Moving to Dallas in 1947, he reconnected with Chicago underworld acquaintances that had also relocated to Dallas, such as Sky Club owner Joe Bonds, who introduced Ruby to the Dallas nightclub scene. The 1950s found Ruby operating the Silver Spur Club—the favorite Dallas hangout of low-level mafiosi, according to police—and the neighboring Ervay Theatre, both offering burlesque. Ruby envied the "class joints" owned by the Weinstein brothers and Dolsen, and ham-handedly maneuvered to join their ranks. Ruby bought into a club at 1312 1/2 Commerce Street (formerly Pappy's 66 Club in the 1930s), which became the Carousel Club in 1961. Although next door to the Colony Club, the Carousel was multiple rungs down the ladder of sophistication. The newspaper advertisement at the top right ran on November 22, 1963; the advertisement at the center right appeared the following two days. In 1964, Ruby was convicted of murder and later died of cancer at Parkland Hospital in 1967. In the late 1960s, the Carousel briefly housed the Dallas Police Association Boxing Club. It was demolished in the early 1970s. (Courtesy Dallas Public Library, NewsBank.)

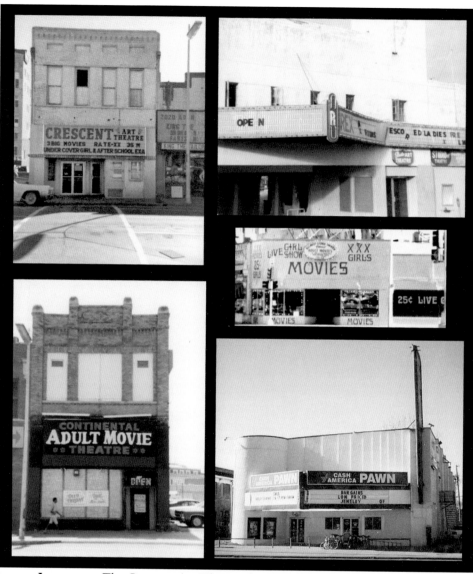

VARIOUS LOCATIONS. The Crescent Art Theatre (top left) at 2100 Elm Street opened in 1966 and was the first non-theatre converted to an adults-only cinema. It closed around 1985 and was demolished. Such storefront adult cinemas were practically identical to those storefront movie houses along Elm Street 60 years earlier (sans piano player). The Rosewin (page 91) reopened in 1964 as the Rex Theatre, an art house. By 1966, it alternated between high-profit hard-core and highbrow art films. Its small, attached storefront was converted into the 80-seat Studio Art Theatre. By 1971, both booked exclusively hard core. Its auditorium roof collapsed soon after closing in 1976. Note daylight from the crumbled auditorium shining through the entrance (top right). The remains were razed in 1981. The Ellwest Stereo Theatre peep show (center right) at 2202 Elm Street operated between 1974 and 1984. It later housed the Metro, a predominantly African American gay bar, and is now vacant. The 1,000-seat Avenue Theatre (bottom right) opened in April 1948 at 4923 Columbia Avenue. Renamed the Guild Theatre in 1968, it soon initiated hard-core programming. Closed around 1989, it is now a pawnshop. The Continental Theatre opened in 1971 at 2036 Commerce Street. Closed in 1986, it remains standing. (Photographs by author.)

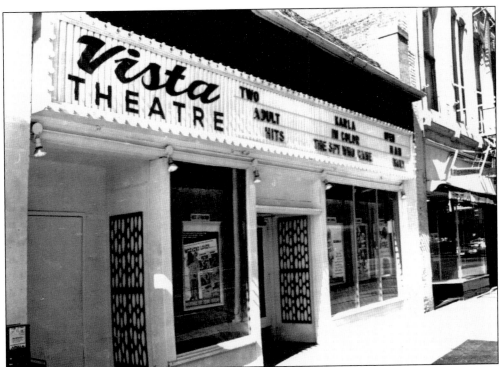

1107 ELM STREET. Located in the center of downtown, the Vista Theatre opened in 1968 with a personal appearance by Swedish sex symbol Britt Eckberg. In the middle of the business district of conservative Dallas, the Vista's arrival—like it or not—hearkened a new era of open sexuality. It closed in 1973 and was demolished. (Courtesy Texas/Dallas Archives, Dallas Public Library.)

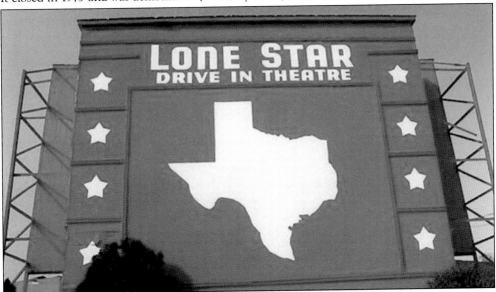

4600 LAWNVIEW AVENUE. The Lone Star Drive-In Theatre opened in February 1951 as a typical drive-in; however, in the 1960s, it became notorious as "that drive-in with the dirty movies." High walls were erected to prevent the films from being visible to the outside world. It closed in the 1990s and has been razed. (Courtesy Jim Wheat.)

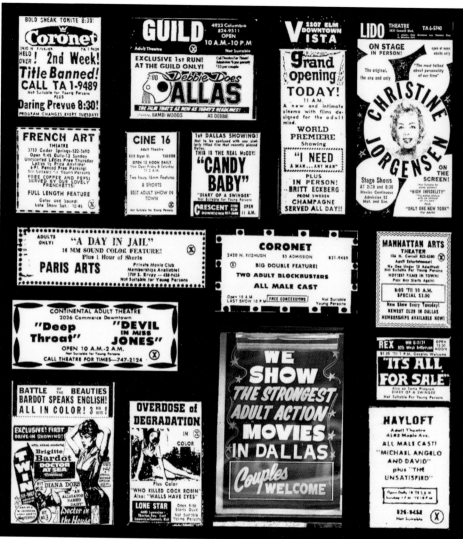

DALLAS DEMIMONDE REDUX. A series of court decisions culminated in 1966 to essentially eliminate most restrictions on hard-core sex films, and a nationwide explosion of new adult film theatres immediately ensued. In 1966, the Coronet Theatre was first to exhibit hard core in Dallas and, in 1974, was first to show all-male hard core. It should be noted that, in 1967, while still an art house, the Rex Theatre was the first in Dallas to target the city's untapped, unseen, and heretofore unimagined gay population by scheduling films such as Andy Milligan's *Vapors* and Kenneth Anger's *Scorpio Rising*, shown together with the iconographic *Rebel Without a Cause*. The Guild Theatre held the Dallas premieres of *Deep Throat* (1972) and *Debbie Does Dallas* (1979). For more than a decade, the Continental Theatre ran only a double feature of *The Devil in Miss Jones* and *Deep Throat*, the most profitable adult movie ever, originally financed by New York's Columbo crime family (whose minions regularly and personally collected 50 percent of the gross profit anywhere it played). Joseph Civello and successive bosses of the Dallas crime family controlled much of the demimonde, including ownership of the Wild Hare and Tamlo Show Lounge burlesque properties (advertisements shown at the bottom of page 64) and, at minimum, two early gay clubs and four adult theatres. Home video closed most adult theatres in the 1980s, and the Internet's emergence in the 1990s sealed the doom of any survivors. (Author's collection.)

Five

EAST DALLAS AND PLEASANT GROVE

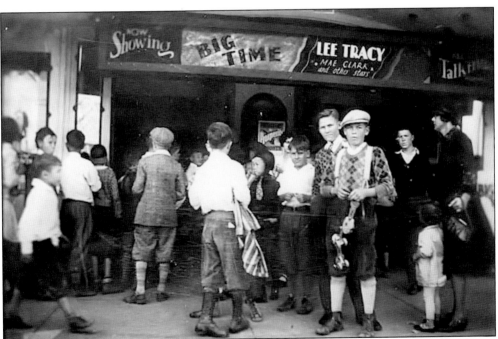

2005 GREENVILLE AVENUE. Were any of these East Dallas kids aware of the hard times to come as they waited to see the Arcadia Theatre matinee, just weeks after the stock market plunged in October 1929? In the words of Jean Genet, "Worse than not realizing the dreams of your youth, would be to have been young and never dreamed at all." (Courtesy Hardin-Simmons University Library, Abilene, Texas.)

4945 Columbia Avenue. The 500-seat Columbia Theatre opened in early 1915 and was acquired by Ed Foy's Neighborhood Theatre chain a year later. In 1921, a Hillgreen-Lane organ was installed to accompany silent films. It was remodeled and reopened as the Rita Theatre on November 22, 1935, with Shirley Temple in *Curly Top*. The Rita closed on March 13, 1948, just weeks before the new Avenue Theatre opened nearby. It is now a bar. (Photograph by author, 2013.)

4304 Bryan Street. Opened in 1916 as part of Ed Foy's Neighborhood Theatre chain, the 550-seat Ideal Theatre was popular with children and adults alike. During World War I, the theatre invited recently returned servicemen to speak about their experiences "over there." On October 26, 1928, a fire blazed through the Ideal, igniting reels of nitrate film and collapsing the roof. The building was repaired and has been used for varied purposes—but never again as a theatre. (Photograph by author, 2013.)

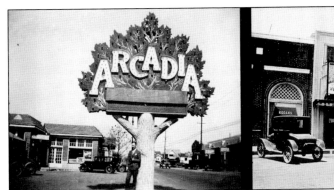

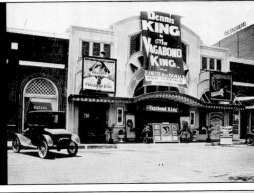

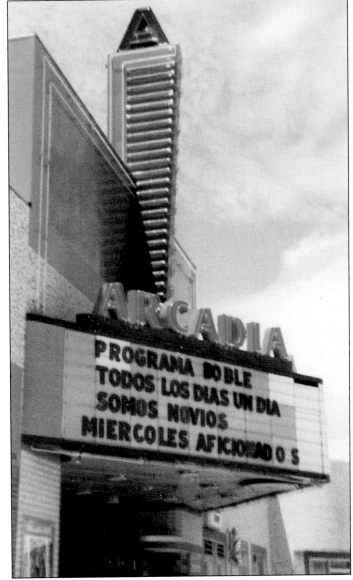

2005 GREENVILLE AVENUE. As the first Dallas theatre designed to accommodate sound (Vitaphone) even before construction began, the Arcadia was regarded as a top neighborhood house. It featured a four-console theatre organ and was the first Dallas theatre to include a cry room. Decorated in an Italian garden motif, the atmospheric auditorium was spectacular, evoking the view from a rooftop garden spanning across the tops of buildings in a Mediterranean town. The ceiling and upper walls "portrayed an Italian night with clouds and twinkling stars." The 1,050-seat Arcadia opened on November 4, 1927, with *The Sunset Derby*, starring Mary Astor. It switched to Spanish-language films in the 1970s and became a nightclub and live music venue from the 1980s through June 2006, when it mysteriously burned to the ground. (Above, courtesy Hardin-Simmons University Library, Abilene, Texas; right, photograph by author, 1977.)

118 NORTH HASKELL AVENUE. The Haskell Theatre was the type of movie house one sees in, well, movies—Captain Marvel serials, ovenware giveaways, and the like. The cozy 450-seat Haskell opened on November 13, 1921, with *Civilian Clothes*. Reopening after two previous fires, the Haskell met its demise in December 1951, when a four-alarm fire gutted the building. It was then home to a chemical company and a bar for at least 10 years before its demolition. (Courtesy Texas/Dallas Archives, Dallas Public Library.)

1315 NORTH PEAK STREET. Opened in May 1929, the 500-seat Peak Theatre was a small, unpretentious neighborhood cinema, much like the nearby Haskell Theatre with a similar clientele. On February 6, 1956, a fire swept through the Peak, causing more than $10,000 in damage. Investigators charged the theatre's 29-year-old operator with arson after discovering petroleum-soaked items throughout the fire-damaged theatre. The building was repaired and used for other purposes before it was eventually razed. (Courtesy Texas/Dallas Archives, Dallas Public Library.)

5437 East Grand Avenue. Opened in 1921, the 400-seat Grand Theatre catered to neighborhood regulars and rarely advertised during its first decade. In 1931, it was remodeled in a classic Art Deco design and significantly enlarged, adding a stage and doubling its seating to 800. It reopened in late 1931 as the East Grand Theatre. It closed in 1952 and has been demolished. (Author's collection.)

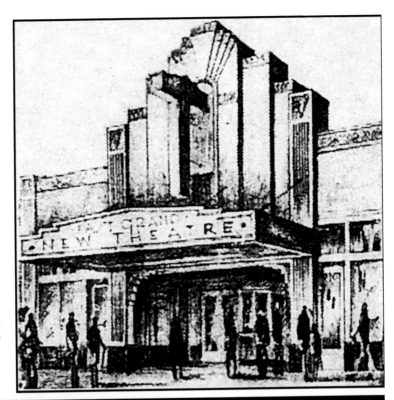

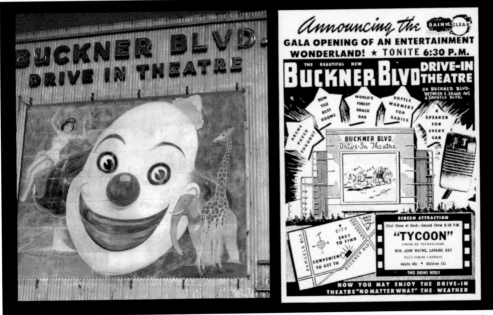

3333 North Buckner Boulevard. Located between Pleasant Grove and White Rock Lake, the Buckner Boulevard Drive-In opened on June 4, 1948, with *Tycoon*, starring John Wayne. The Buckner featured a children's playground beneath the screen, outdoor seating, and individual speakers for each automobile. The Buckner was a year shy of its 30th anniversary when it closed in 1977. It has since been demolished. (Courtesy Jim Wheat.)

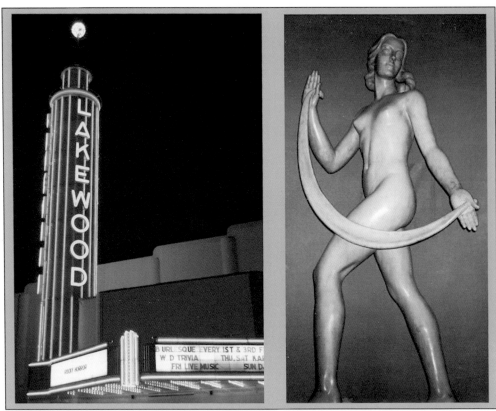

1825 ABRAMS ROAD. Relatively unaltered, the Lakewood Theatre is the best remaining example of an Art Deco theatre in Dallas. Built by Interstate Amusement Company, the Lakewood opened on October 27, 1938, with *Love Finds Andy Hardy*, starring Mickey Rooney. Dallas artists created the lobby murals, and its 100-foot neon tower is a Dallas landmark. The Lakewood currently offers a wide variety of live shows and films. (Above, photograph by author, 2013; below, courtesy of the Lakewood Theatre.)

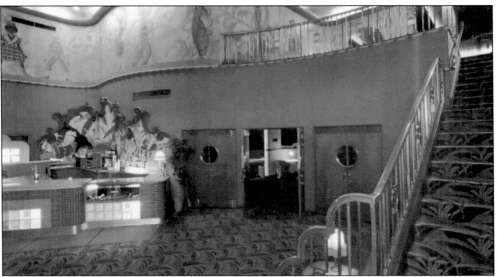

150 CASA LINDA PLAZA. Part of B.L. McClendon's theatre chain, the 959-seat Casa Linda Theatre opened on August 9, 1945, with *The Affairs of Susan*, starring Joan Fontaine. In 1965, it became the first multiscreen in Dallas after it was divided into two screens. In the 1970s, it was divided into three screens. In 2011, it was gutted for a grocery store, but still retains much of its original exterior, including the neon tower. (Courtesy Randy A. Carlisle, RAC Photography.)

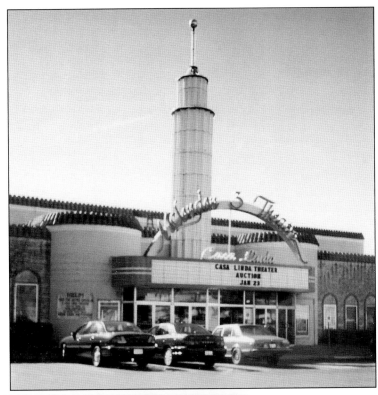

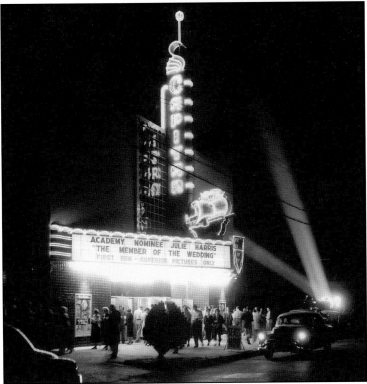

2400 NORTH HENDERSON AVENUE. The 1,400-seat Capitan Theatre opened on August 23, 1946, with *Do You Love Me?* starring Maureen O'Hara. Designed with a pirate theme, the marquee included a ship, and the lobby murals depicted seascapes and Spanish galleons. It closed in 1955 and was remodeled to become the Capitan Bowling Alley. It has since been demolished. (Courtesy Texas/Dallas Archives, Dallas Public Library.)

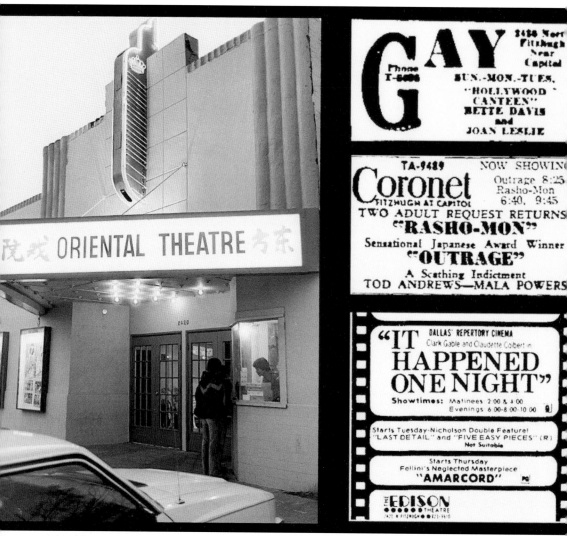

2420 NORTH FITZHUGH AVENUE. Opened on March 6, 1942, with *Lady Be Good*, the Gay Theatre's 500 leather and blue mohair upholstered seats included some extra-wide "love seats." It closed and reopened in 1948 as the Coronet Theatre, a foreign and art film house owned by Alfred Sack, whose Sack Amusement Company had produced and distributed African American "race films" since the 1920s and, later, moved into adult film production. Likewise, the Coronet gradually drifted toward racier foreign films until reaching exclusively hard-core adult features in the mid-1960s. In 1976, it closed and reopened as the Edison Theatre, showing classics and legitimate art films until closing in 1978. Around 1982, it reopened with Spanish-language movies as the Cine Mexico. Soon after, it became the Oriental Theatre, with films in several Asian languages. It was demolished around 1993. Truth is indeed stranger than fiction: originally opened as the Gay Theatre by a man known as I. Gay, it was later managed briefly by Frances Ethel Gumm, mother of gay icon Judy Garland. Years later, it became the first theatre in town to show all-male adult films. (Courtesy Texas/Dallas Archives, Dallas Public Library.)

3524 Greenville Avenue. The 950-seat Granada Theatre opened on January 16, 1946, with *Mildred Pierce,* starring Joan Crawford. The auditorium was constructed using a special plaster to improve acoustics, and a soundproof cry room was provided. The theatre was part of the chain owned by Phil Isley, father of film star Jennifer Jones and father-in-law of the legendary David O. Selznick. The Granada now operates as a live music venue. (Courtesy Randy A. Carlisle, RAC Photography.)

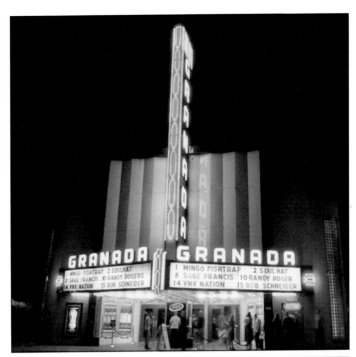

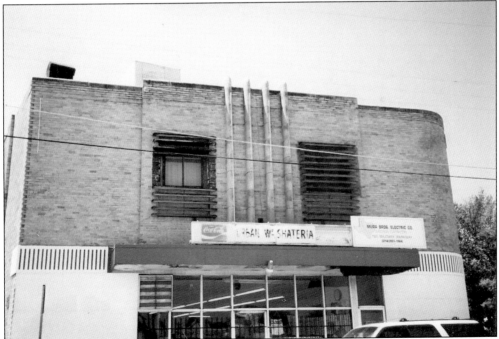

7106 Military Parkway. The first Urban Theatre (7035 Military Parkway) opened on January 24, 1941, and was completed destroyed by a fire in April 1944. A new 1,000-seat Urban Theatre, built across the street from the first, opened on July 13, 1945, with *Music for Millions,* starring Margaret O'Brien. Closing in 1957, it became the Urbandale Youth Center later that year, providing activities for teenagers. In the 1960s, it became a washateria and is now scheduled for demolition. (Photograph by author, 1999.)

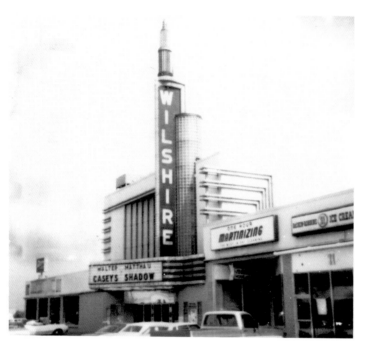

6106 EAST MOCKINGBIRD LANE. Opened on October 4, 1946, with *Rendezvous with Annie*, starring Eddie Albert, the Wilshire Theatre's opening festivities also included klieg lights and a live demonstration of television by local comedian "Uncle" Willie Pratt. The Art Moderne theatre included 832 push-back seats, a floral motif, and Chrysler air-conditioning. It closed on April 23, 1978, with Walter Matthau in *Casey's Shadow*. It was demolished within a few months. (Photograph by author, 1978.)

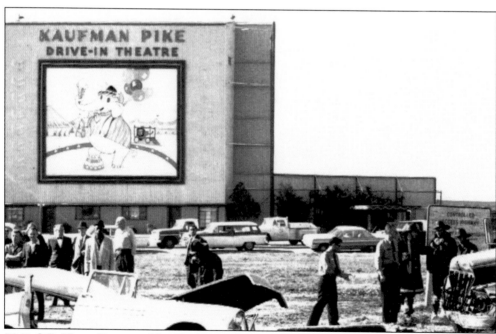

7041 C.F. HAWN FREEWAY. The Kaufman Pike Drive-In opened on July 1, 1949, with *Montana Mike*, starring Robert Cummings. It featured a children's playground and the "latest RCA in-car speakers." It closed in the summer of 1983 and was demolished. This photograph shows a serious auto accident in front of the drive-in. (Courtesy Texas/Dallas Archives, Dallas Public Library.)

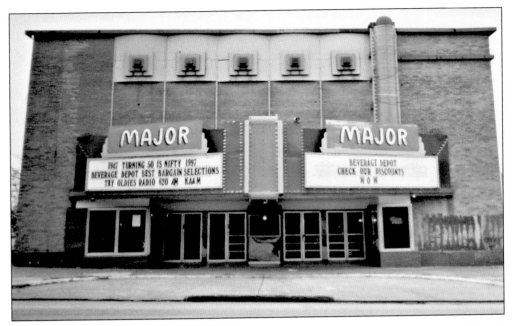

2830 SAMUELL BOULEVARD. Opened on May 30, 1947, with *California*, starring Ray Milland, and personal appearances by Chill Wills and Monte Hale, the 1,100-seat Major Theatre was jointly owned by Maj. L.M. Childers and the Phil Isley theatre chain. In 1965, it became the Lido Theatre, offering adult films and live burlesque until closing in the late 1980s. Around 1993, the installation of a new marquee resurrected its old name—the Major—and the new owners put forth a noble but short-lived effort to operate as a revival/art house. It now houses an advertising company's offices. (Above, photograph by Randy A. Carlisle, RAC Photography; below, author's collection.)

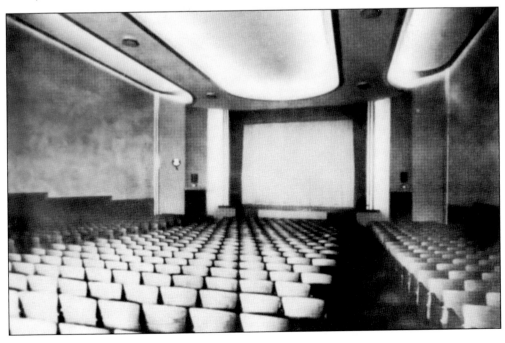

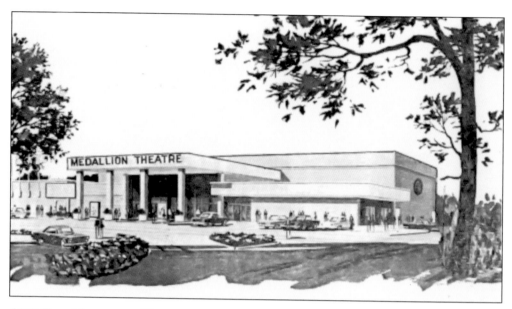

6400 EAST NORTHWEST HIGHWAY. Opened on October 30, 1969, with *Butch Cassidy and the Sundance Kid*, the 880-seat Medallion Theatre was the last of those built by Interstate in Dallas. Through much of the 1970s, the Medallion was one of the city's top houses, with exclusive engagements of such blockbusters as *The Godfather*. The photograph below shows a crowd awaiting the next showing of *Close Encounters of the Third Kind* in December 1977. When an out-of-state corporation purchased Interstate in 1978, Dallas lost an old friend. Under a series of new owners, the Medallion plummeted from one of the prime theatres to possibly the worst in town, becoming a multiplexed dollar cinema where delinquents ran amok without a word from management (much less parents). The auditoriums were filthy, and robberies in the parking lot were common. It closed around 1990 and was demolished. (Above, author's collection; below, courtesy Texas/Dallas Archives, Dallas Public Library.)

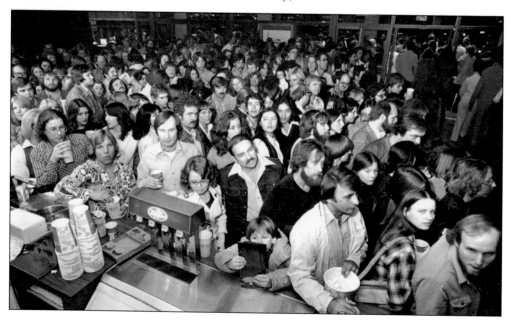

Six

SOUTH DALLAS
AND FAIR PARK

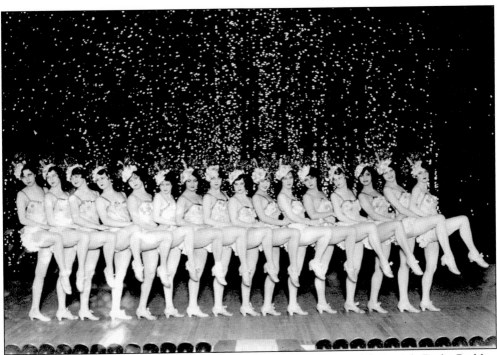

DREAM GIRL FOLLIES, 1934. The *Dream Girl Follies*, a glitzy song and dance à la Busby Berkley, was one of many events marking the beginning of the Texas Centennial celebration at Fair Park, and it was just one of approximately 1,000 shows and 15,000 performances given on the Fair Park Music Hall stage throughout its near 90-year history. (Courtesy Mary McCord/Edyth Renshaw Collection on the Performing Arts, Jerry Bywaters Special Collections, Hamon Arts Library, Southern Methodist University.)

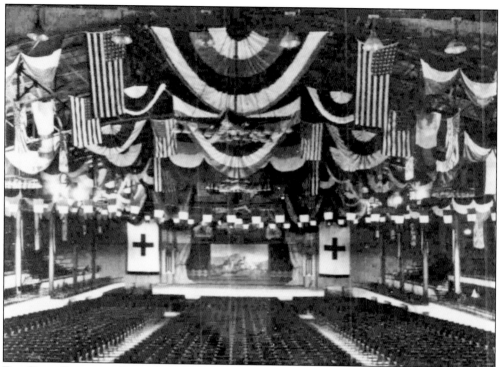

FAIR PARK COLISEUM. Opened in 1910, the Coliseum seated 3,000 in the theatre portion, which could be combined with the adjoining arena section to create a convention hall seating 8,000. The Coliseum's arena featured horse and livestock shows, as well as new-car shows, which were found in the basement during the fair. Exhibitor booths could be set up anywhere throughout the complex. Despite the cavernous building's terrible acoustics, the Coliseum's huge 50-by-36-foot stage and 24 dressing rooms made it a frequent venue for plays and musicals. When the Music Hall opened in 1925, the Coliseum was used primarily for horse and livestock shows and, later, housed the state fair's administrative offices. It was renovated to become the Women's Museum of Dallas in 2000, but forced to close in 2011 due to lack of funding. (Above, courtesy Texas/Dallas Archives, Dallas Public Library; below, photograph by Andreas Praefcke.)

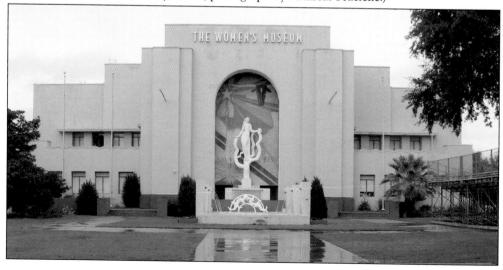

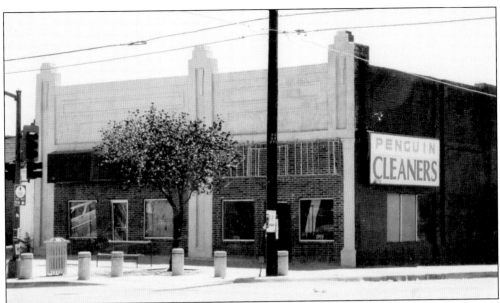

1702 Forest Avenue (Now Martin Luther King Jr. Boulevard). Opened in 1914, the 425-seat Colonial Theatre was one of the first neighborhood theatres in the city. It changed its name to the Forest Theatre in the late 1920s, but when the new Forest Theatre opened down the street in 1949, it returned to the original Colonial name. The change was brief, however, because, in late 1949, it became Barney Weinstein's Theatre Lounge. It is currently used by a dry cleaner. (Photograph by author, 1999.)

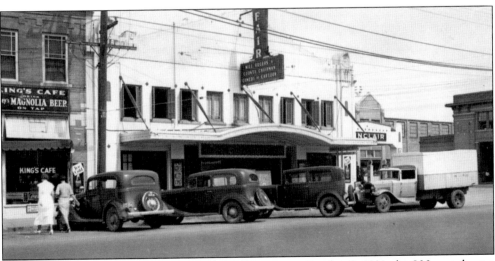

3711 Parry Avenue. Opened as the Parkway Theatre on October 2, 1921, the 800-seat theatre directly across the street from Fair Park changed its name to the Fair Theatre in 1933. South Dallas experienced turbulence following World War II as black families began buying homes in all-white neighborhoods. In 1949, when the theatre switched from all-white to all-black admittance, anonymous notes arrived demanding it be returned "back to the whites." Less than a month later, a late-night fire destroyed the theatre. Investigators determined it arson, but no suspects were ever found. (Courtesy Texas/Dallas Archives, Dallas Public Library.)

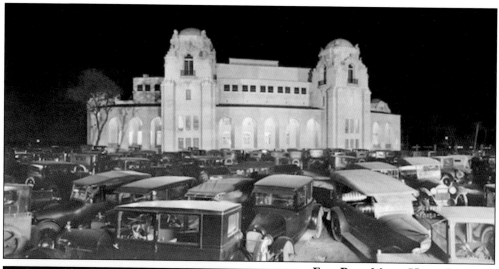

FAIR PARK MUSIC HALL. Seen here on opening night in October 1925 with a production of *The Student Prince*, the $500,000 State Fair Music Hall (also known as the State Fair Auditorium) seated 4,500 and, later, changed its name to the Fair Park Music Hall. For more than 75 years, it was home to organizations such as the Dallas Symphony, Dallas Opera, and Dallas Ballet. It is still used year-round, particularly for musical theatre. (Courtesy Jim Wheat.)

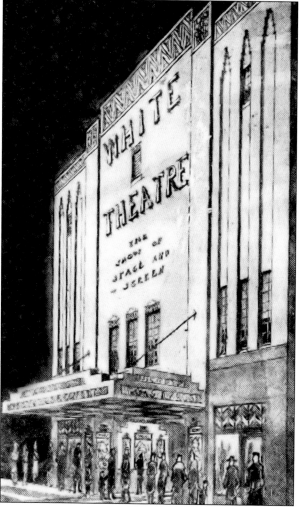

2720 FOREST AVENUE (NOW MARTIN LUTHER KING JR. BOULEVARD). Local theatre owner M.S. White opened the White Theatre on January 6, 1934, with *Saturday's Millions*. The 1,000-seat theatre also included a large stage. It later became part of the Interstate Amusement Company chain for several years. In 1956, after this part of South Dallas became predominantly black, it changed its name to the Elite Theatre and operated for about two years. It has since been demolished. (Author's collection.)

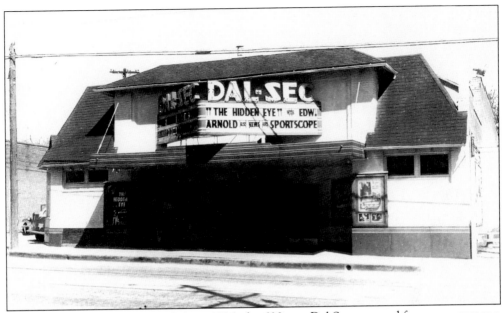

1900 Second Avenue. Opened about 1926, the 600-seat Dal-Sec operated for many years as a simple little neighborhood theatre. In the 1930s and 1940s, it was part of the Interstate chain. It closed and was demolished in 1969 for a Fair Park expansion project. (Courtesy Texas/Dallas Archives, Dallas Public Library.)

1709 South Ervay Street. Opened by three ex-GI's on December 22, 1946, the 550-seat Ervay Theatre served the old Cedars neighborhood, just south of downtown. In the early 1950s, Jack Ruby managed it as a burlesque house. It then operated as the Paris Art Cinema between the years of 1968–1975, offering hard-core adult films. It is now used for commercial and residential space. (Photograph by author, 1978.)

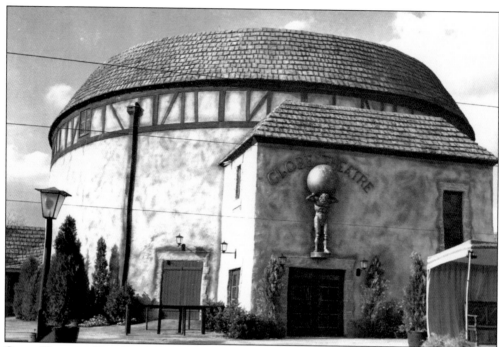

GLOBE THEATRE, FAIR PARK. Opened for the Texas Centennial in 1936, the Globe Theatre was an authentic replica of Shakespeare's famous Globe in England. It offered condensed versions of Shakespearean plays several times daily throughout the fair. After the Centennial, Margo Jones and the Dallas Civic Theatre/Theatre '45 used the space until its unannounced demolition in April 1946, an event that shocked many in the theatre community, especially Jones. (Courtesy Texas/Dallas Archives, Dallas Public Library.)

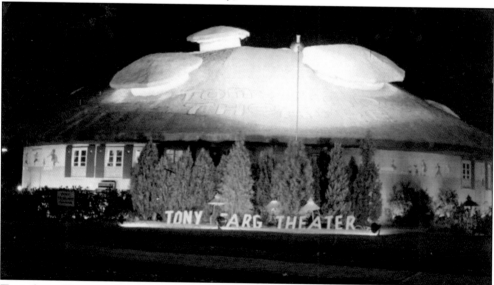

TONY SARG THEATRE, FAIR PARK. Named for the nationally renowned puppeteer, the Tony Sarg Theatre was opened for the Texas Centennial in 1936. Fairy tale–based marionette shows were offered hourly throughout the fair. It was demolished in the late 1930s. (Courtesy Texas/Dallas Archives, Dallas Public Library.)

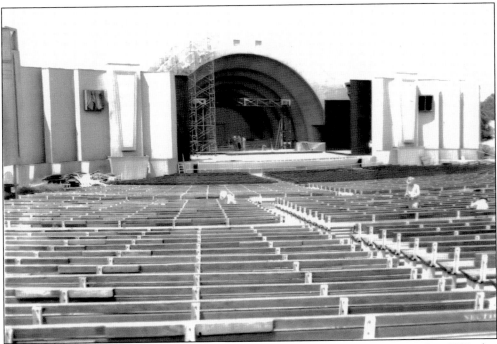

FAIR PARK BANDSHELL. Opened as the State Fair Casino for the Texas Centennial in 1936, this venue is now commonly known as the Fair Park Bandshell. The 5,000-seat amphitheater was home to the annual Starlight Musical series from 1941 to 1951 and the Shakespearean Festival of Dallas in the 1970s and 1980s. It has recently undergone renovations. (Courtesy Texas/Dallas Archives, Dallas Public Library.)

4302 SECOND AVENUE. Opened on June 9, 1948, with *Song of Scheherazade*, starring Yvonne De Carlo, the 1,000-seat Lagow Theatre was a moderately successful neighborhood house before closing around 1970. It has been home to several churches since then. (Photograph by author, 1999.)

MARGO JONES AND FAIR PARK'S MAGNOLIA LOUNGE. Native Texan Margo Jones (above, holding script) traveled worldwide studying live theatre and, between trips, worked as a theatre professor, director, and producer throughout the United States. Jones believed that new works should be produced nationwide rather than be limited to Broadway. She launched the American regional theatre movement when she opened Theatre '47 in Fair Park's Magnolia Lounge, a sleek European Modernist building designed by William Lescaze for the Texas Centennial. It was America's first professional theatre-in-the-round, as well as its first nonprofit professional resident theatre. Each New Year's, the theatre celebrated with traditional black-eyed peas and a ceremony to change the year of the theatre sign at midnight—Theatre '48, '49, and so on. Margo Jones and her theatre helped launch the careers of Tennessee Williams, Jerome Lawrence, William Inge, Jack Warden, Brenda Vaccaro, Larry Hagman, and many others. Jones died after unknowingly inhaling toxic fumes from a carpet-cleaning solution in 1955, and her theatre closed in 1959. In 2010, the Nouveau 47 Theatre acquired the Magnolia Lounge, returning it to theatrical use for the first time in 50 years. (Both, courtesy Texas/Dallas Archives, Dallas Public Library.)

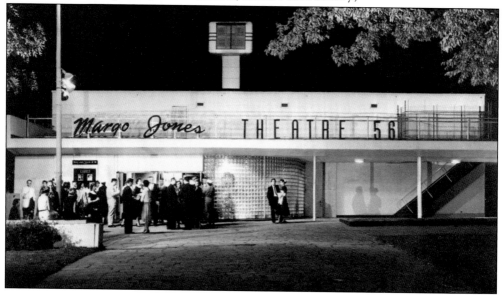

Seven

OAK CLIFF

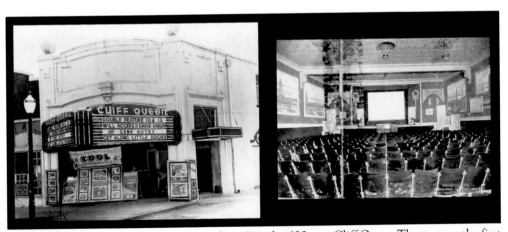

616 EAST JEFFERSON BOULEVARD. Opened in 1914, the 600-seat Cliff Queen Theatre was the first neighborhood theatre in Oak Cliff and one of the most popular. It was acquired by the Rowley chain, then later by Gene Autry's theatre chain before closing around 1952. It has since been demolished. (Left, courtesy Texas/Dallas Archives, Dallas Public Library; right, courtesy of the George Blackburn family.)

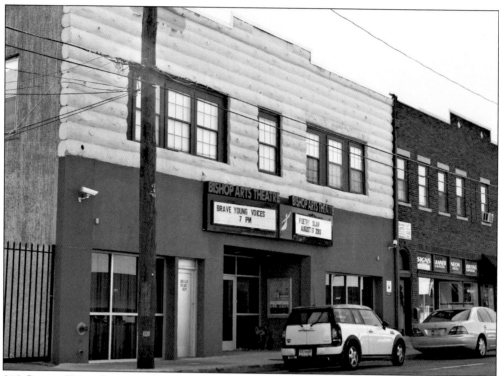

213 SOUTH TYLER STREET. The Bluebird Theatre, opened around 1915, operated until 1923 as a neighborhood movie house and was then used for a variety of purposes, including a record shop. The original exterior resembled a Bavarian cuckoo clock—a log cabin with a mechanical bluebird flying a circular path in and out of a faux window above the marquee. Amazingly, the simulated log facade (actually concrete) has survived almost 100 years. The building was renovated and reopened as the Bishop Arts Theatre Center in 2008, which contains a 170-seat theatre, art gallery, offices, and classrooms. More information can be found on page 127. (Above, photograph by author, 2013; below, photograph by Jacquie Patrick.)

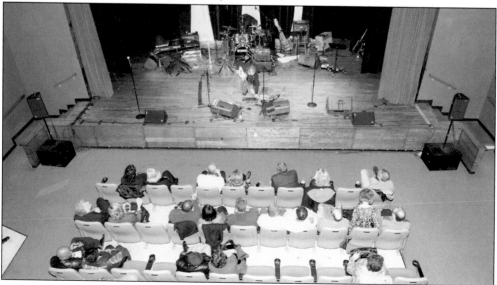

410 NORTH BISHOP AVENUE. Part of Foy's Neighborhood Theatre chain, the 600-seat Rialto Theatre opened with *The Westerners* on November 6, 1919. It later became the Avenue Theatre in 1930, the Bishop Avenue Theatre in 1933, and finally, the Astor Theatre in 1934. It closed in the early 1950s, becoming the Astor Lounge soon after, followed by a warehouse. It is now used for retail space in the revitalized area known as the Bishop Arts District. (Courtesy Bob Johnston.)

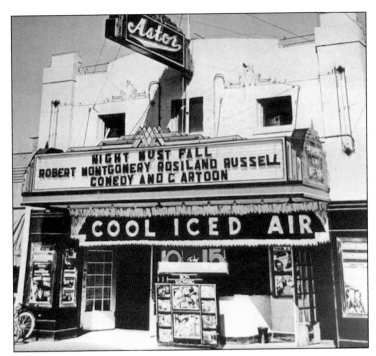

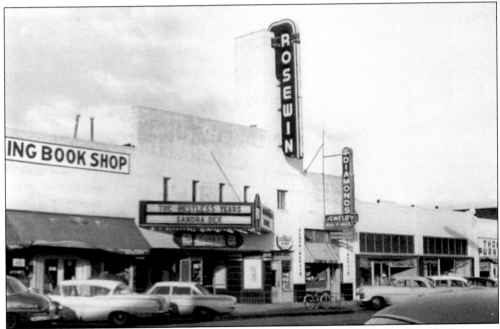

925–927 WEST JEFFERSON BOULEVARD. The Rosewin Theatre derived its name from the Rosemont and Winnetka neighborhoods it served. From its opening on July 27, 1922, with *The Little Minister*, the 600-seat theatre remained a popular neighborhood house until closing in 1964. It reopened later that year as the Rex Theatre, an art house that moved to hard-core adult films in 1970. It has been demolished. More information can be found in Chapter Four. (Courtesy Bob Johnston.)

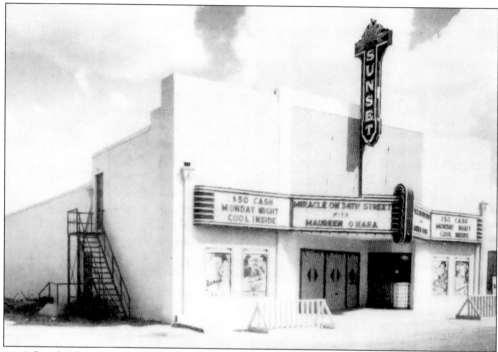

1112 South Hampton Road. Opened on December 20, 1925, with *The Shooting of Dan McGrew* starring Lew Cody, the 500-seat Sunset Theatre, named for nearby Sunset High School, was a simple movie house catering to the neighborhood (once known as "Jimtown"). Westerns, double features, and serials were very popular. It closed on June 10, 1955, with a triple feature: *Magnificent Obsession*, *New Orleans Uncensored*, and *It Came from Outer Space*. Since then, it has been used for storage by a lumberyard and hardware store. (Both, author's collection.)

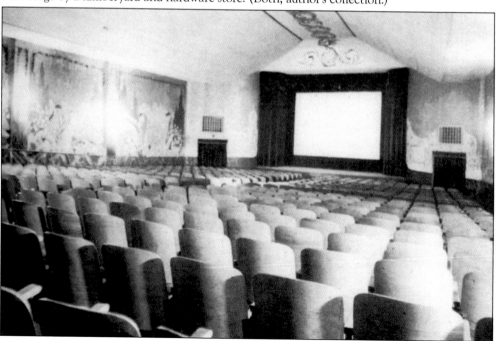

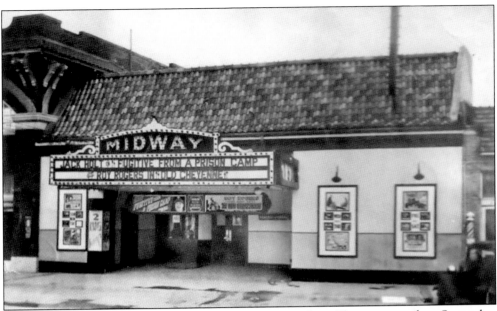

110–112 WEST JEFFERSON BOULEVARD. The 600-seat Midway Theatre opened on September 26, 1922, with *Shackles of Gold*, starring William Farnum. For years, it was a popular fixture on Jefferson Boulevard, especially with children on Saturday afternoons. Since closing in 1958, it has been used as an appliance store, a Mexican restaurant, and currently, a clothing store. (Courtesy Bob Johnston.)

1730 SOUTH EWING AVENUE. Named for the Trinity Heights area of Oak Cliff, the 650-seat Trinity Theatre opened on July 17, 1927, with *While London Sleeps*, starring Rin Tin Tin. At a cost of $40,000, the theatre featured a decorative fountain in the lobby, a Fotoplayer to accompany silent films, and probably the first cry room in Dallas. It closed in December 1951 and briefly reopened as the Ewing Theatre in 1955. Since then, it has been used as a church. (Photographs by author, 1999.)

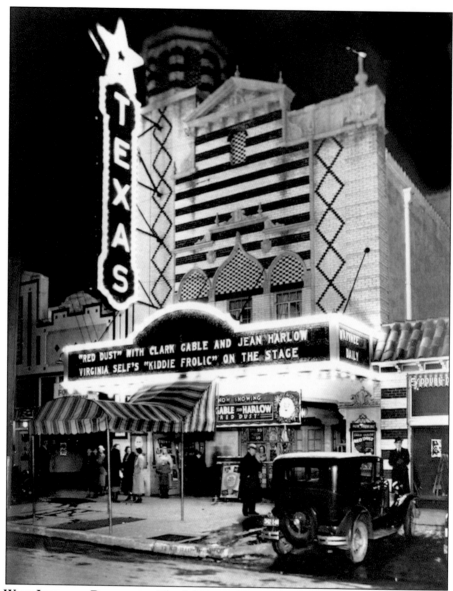

231 WEST JEFFERSON BOULEVARD. The 2,000-seat Texas Theatre opened on April 21, 1931, with *Parlor, Bedroom and Bath*, starring Buster Keaton (in one of his first sound films). Part of the Robb and Rowley theatre chain (which was then owned by legendary Texas billionaire Howard Hughes), the Texas was considered the finest in Oak Cliff and was larger than any other neighborhood theatre in Dallas. Designed in an atmospheric Italian Renaissance style by architect W. Scott Dunne, the auditorium was decorated with three-dimensional scenery to create the atmosphere of a 16th-century Italian village, complete with night sky, clouds, and twinkling star effects in the ceiling. However splendid and unique these elements might have been, the misfortune of its random involvement with the Kennedy assassination would cause the Texas Theatre to suffer. Like many others in Dallas, the theatre's corporate executives sought to avoid any reminders of the tragedy—to act as if it never happened. As a result, they buried the original 1931 architectural details beneath thick layers of stucco, almost as if to purify the building inside and out with thick, white mud. (Courtesy Texas/Dallas Archives, Dallas Public Library.)

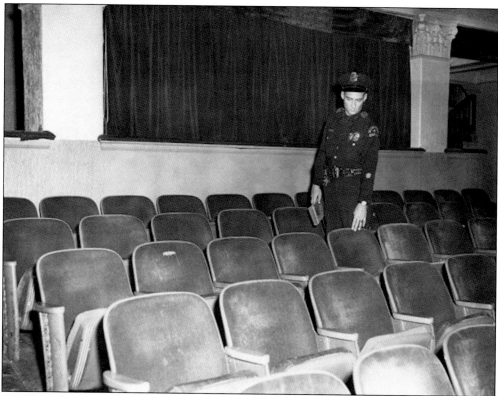

231 WEST JEFFERSON BOULEVARD. Remodeling notwithstanding, the Texas Theatre will be known forever as the site of Lee Harvey Oswald's arrest following the assassination of Pres. John F. Kennedy on November 22, 1963. Tour buses shuttle hundreds of the curious to and from the theatre each day. Unfortunately, while seeking some hidden clue, some conspiratorial evidence yet uncovered, some drop of blood or some spectral manifestation, these misguided onlookers fail to see the multitude of spirits that truly pervade. For over 80 years, thousands have sought respite within this grand old building and have come away a bit happier, perhaps a bit wiser, or at least, a bit less weary. The Texas has survived, helped by many, including some celebrities. Filmmaker Oliver Stone, while making *JFK*, funded the restoration of the original 1931 facade from its 1964 corporate-inspired "stucc-over" (shown at right). Legendary Texas musician Don Henley contributed a significant sum for its restoration, as did a number of generous foundations. Most help, however, simply came from caring citizens unknown and unseen, "all those wonderful people in the dark." (Above, courtesy Dallas Municipal Archives; right, photograph by author, 1978.)

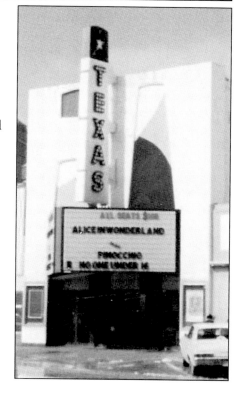

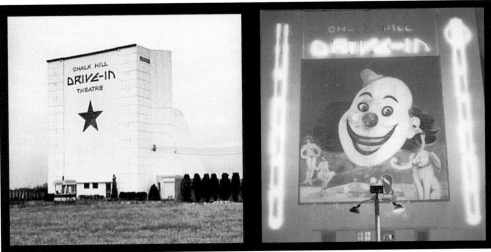

4501 WEST DAVIS STREET. When the Chalk Hill Drive-In opened on July 4, 1941, with *The Invisible Woman*, starring Virginia Bruce and John Barrymore, it was almost the first drive-in of Dallas, beat to the punch by the Northwest Highway Drive-in just three weeks earlier. Its famous clown mural was added in the 1950s, covering its original star painting. Operating through the 1970s, it has since been demolished. (Courtesy Texas/Dallas Archives, Dallas Public Library.)

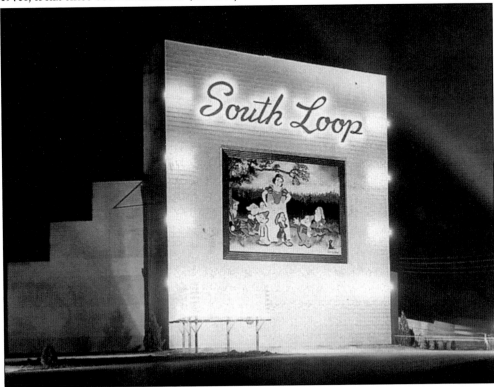

3142 SOUTH LOOP 12. The South Loop Drive-In opened on March 30, 1950, with *On the Town*, starring Gene Kelly and Frank Sinatra. At a cost of $150,000, the drive-in featured a playground, indirect walkway lighting, individual car speakers, and what became the famous *Snow White* mural. It closed in 1975 and has been demolished. (Courtesy Dallas Public Library, NewsBank.)

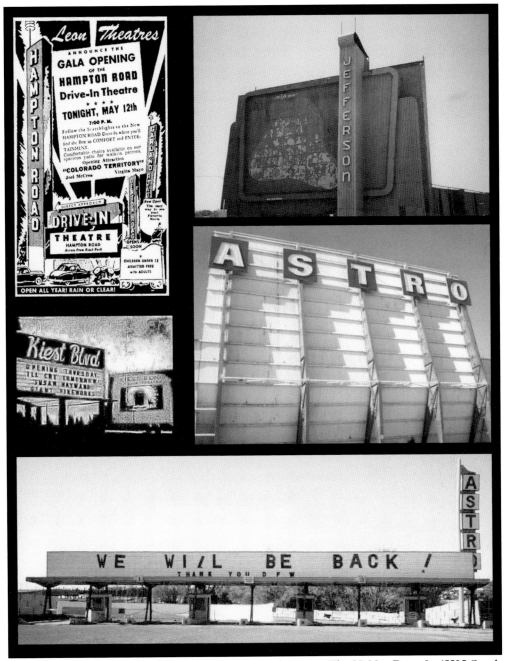

VARIOUS LOCATIONS. Oak Cliff was home to many drive-ins. The Hi-Vue Drive-In (5525 South Beckley Avenue) opened on July 1, 1949, and was demolished around 1978. The Hampton Road Drive-In (2833 South Hampton Road) opened on May 12, 1950, and was demolished around 1979. The Jefferson Drive-In (4506 West Jefferson Boulevard) opened on June 17, 1950, and was demolished in 2004. The Kiest Drive-In (3100 East Kiest Boulevard) opened on May 24, 1956, and was demolished around 1991. The three-screen Astro Drive-In (3141 South Walton Walker) opened on August 2, 1969, and was demolished in 1999. (Astro photographs courtesy Randy A. Carlisle, RAC Photography; Jefferson photograph by author, 1998; all others, author's collection.)

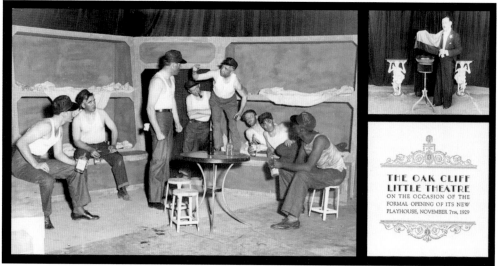

1015 North Crawford. The Oak Cliff Little Theatre (OCLT) was organized in 1926, performing plays in the Rialto Theatre on Bishop Street and the Oak Cliff (Adamson) High School auditorium. Benefactor Charles Mangold, who had built Lake Cliff Park, donated the land for a permanent OCLT building. Opened on November 7, 1929, with a production of *The Inheritors*, the new 200-seat theatre was described as "simple, yet elegant," with good sightlines, excellent acoustics, a cream-colored interior, and a domed ceiling. The critically acclaimed OCLT often used mixed-race casts (illustrated here in their 1932 production of O'Neill's *The Hairy Ape*), which provoked significant controversy. Financial problems forced OCLT to close in 1935. The building was later used as a dance school, artist studio, and a residence before its 1966 demolition. (Courtesy Mary McCord/Edyth Renshaw Collection on the Performing Arts, Jerry Bywaters Special Collections, Hamon Arts Library, Southern Methodist University.)

3203 West Davis Street. The first art house in Dallas, the 812-seat Beverly Hills Theatre opened on September 2, 1944, with *Lassie Come Home*. The format proved unsuccessful, however, and management switched to standard fare. It closed around 1960 and has since been occupied by several churches. (Courtesy Texas/Dallas Archives, Dallas Public Library.)

1230 WEST DAVIS STREET. The Streamline Moderne Kessler Theatre is a survivor. Taking its name from the prestigious Kessler Park area nearby, the theatre opened on March 1, 1942, with *You'll Never Get Rich*, starring Fred Astaire, then closed only 10 years later in January 1952. The building became home to a "fire and brimstone" revivalist church later that year. Oak Cliff's infamous 1957 tornado flattened the building's auditorium (shown below), but the damage was repaired, only to again suffer near total destruction of the auditorium a few years later, this time by a massive fire. The church relocated, but the owner rebuilt again. For the next 20 years or so, it was home to a manufacturer of embroidered bowling shirts. It went vacant until 2009, when its new owner renovated from foundation up, transforming it into one of the most popular venues in Dallas for live performances. (Above, photograph by author, 2013; below, courtesy Texas/Dallas Archives, Dallas Public Library.)

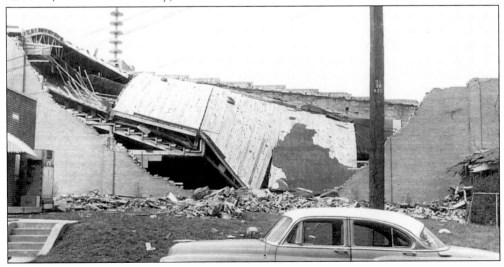

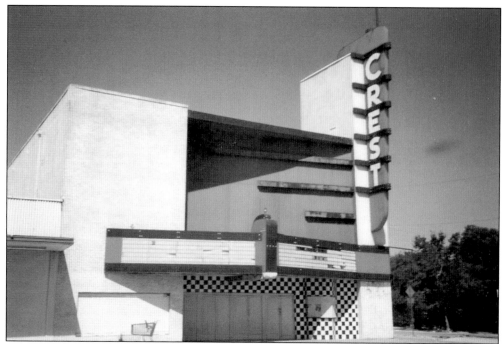

2603 South Lancaster Road. Phil Isley's 950-seat Crest Theatre opened on March 30, 1948, with *Cass Timberlane*, starring Spencer Tracy and Lana Turner. The theatre, featuring push-back seats and a sunken lounge area, took its name from Oak Cliff's new Cedar Crest subdivision. Closed around 1979, it sat vacant for decades before its demolition in 2008. (Photograph by author, 1998.)

2111 South Beckley Avenue. Built and operated by Gene Autry Enterprises, the 800-seat Beckley Theatre opened on September 25, 1946, with *The Bride Wore Boots*, starring Barbara Stanwyck. It was not especially successful and closed in 1956. It has since been home to several churches. (Photograph by author, 1999.)

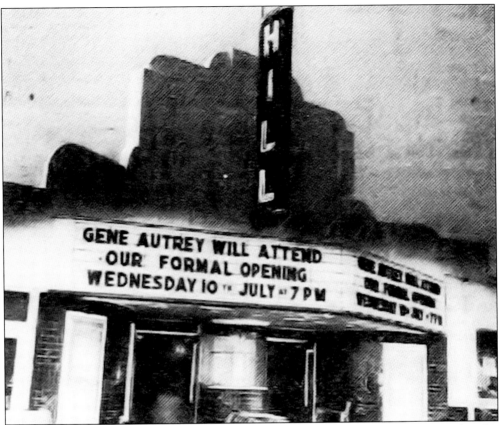

4334 West Jefferson Boulevard. Also built and operated by Gene Autry Enterprises, the 850-seat Hill Theatre opened on July 10, 1946, with *Swing Parade of 1946*, starring Gale Storm and the Three Stooges. Autry made a personal appearance at the opening ceremonies of the Hill, named for its location in the small "island" city of Cockrell Hill. Losing money from the beginning, it closed just six years later in 1952, then operated as an auto parts store before being demolished in 1999. (Above, author's collection; below, photograph by author, 1998.)

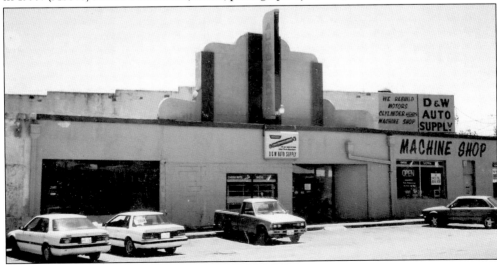

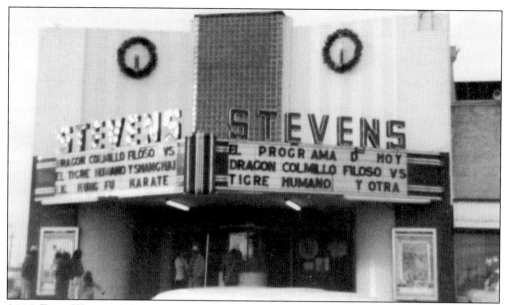

2007 Fort Worth Avenue. Built and operated by the Rowley chain, the 850-seat Stevens Theatre opened on January 24, 1946, with *Kiss and Tell*, starring Shirley Temple. It took its name from its location in Oak Cliff's Stevens Park area. In 1962, the Stevens became the second Spanish-language theatre operating in Dallas. It closed around 1988 and was demolished soon after. (Photograph by author, 1978.)

3103 Falls Drive. Also built and operated by the Rowley chain, the 800-seat Heights Theatre opened on October 28, 1949, with a live appearance by Dallas comedian "Uncle" Willie Pratt and *The Girl from Jones Beach*, starring Ronald Reagan. Named for the Westmoreland Heights area, it enjoyed only moderate success. In the early 1970s, it shifted to Spanish-language films, again with only mediocre results. It closed c. 1980, and has since been home to a Hispanic church. (Photograph by author, 1978.)

2010 West Jefferson Boulevard. Named for the mascot of Sunset High School next door, the 500-seat Bison Theatre opened on August 27, 1927, with *The Mysterious Rider*, starring Jack Holt. Future Hollywood beauty Linda Darnell frequented the Bison as an Oak Cliff teenager. Darnell is shown below being welcomed home on the steps of Dallas City Hall. The Bison closed and was demolished in 1948 so the site could be used to build the larger, more modern 1,050-seat Vogue Theatre, which opened on March 22, 1949, with *Blood on the Sand*, starring Robert Mitchum. Part of the Rowley chain, the Vogue operated through the late 1970s, when it became a church and "Jesus" replaced "Vogue" on the vertical sign (shown at right). It made a brief but unsuccessful return to movies in the 1980s and has been home to a Hispanic church since then. (Right, photograph by author, 1979; below, courtesy Mary McCord/Edyth Renshaw Collection on the Performing Arts, Jerry Bywaters Special Collections, Hamon Arts Library, Southern Methodist University.)

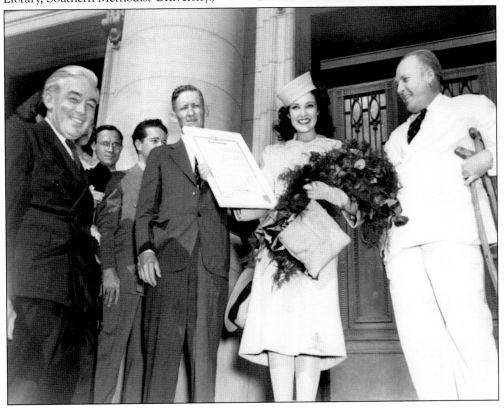

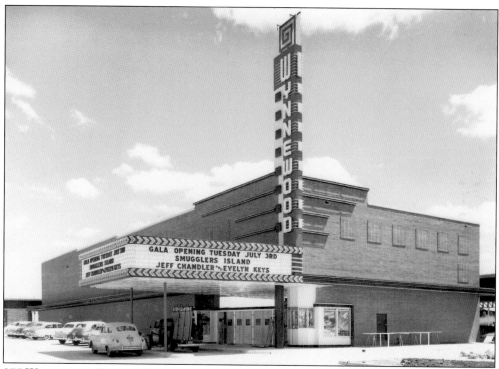

275 WYNNEWOOD VILLAGE. Featuring a circular lobby and a cry room, the 1,000-seat Wynnewood Theatre opened on July 3, 1951, with *Smuggler's Island*, starring Jeff Chandler. Frequent showings of Disney films made it popular among children. Part of the Rowley chain, it was twinned in 1975, then closed in 1983, and finally, demolished in 1999. (Courtesy Texas/Dallas Archives, Dallas Public Library.)

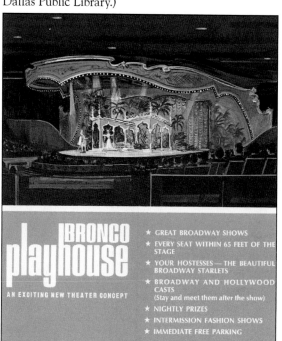

2600 FORT WORTH AVENUE. The 3,000-seat Bronco Theatre/Coliseum was part of the Bronco Bowl complex, which opened on August 31, 1961, with a personal appearance by Hollywood bombshell and former Dallasite Jayne Mansfield. In the late 1960s, it hosted Broadway road shows and local productions, and from about 1978 to 2002, its outstanding sightlines and acoustics made it a popular venue for concerts, featuring such artists as Bob Dylan, Bruce Springsteen, and the Clash. The Bronco Bowling Alley and its theatre were demolished for a home improvement store in 2003. (Courtesy Mary McCord/Edyth Renshaw Collection on the Performing Arts, Jerry Bywaters Special Collections, Hamon Arts Library, Southern Methodist University.)

Eight

NORTH DALLAS
AND PARK CITIES

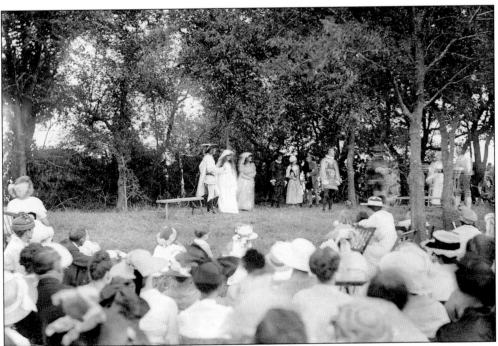

ARDEN CLUB, SOUTHERN METHODIST UNIVERSITY, 1916. Since its founding in 1911, Southern Methodist University has been integral to the performing arts in Dallas. Today, the campus is home to six theatres including the Bob Hope, the Greer Garson, and the Margo Jones Theatres. (Courtesy Mary McCord/Edyth Renshaw Collection on the Performing Arts, Jerry Bywaters Special Collections, Hamon Arts Library, Southern Methodist University.)

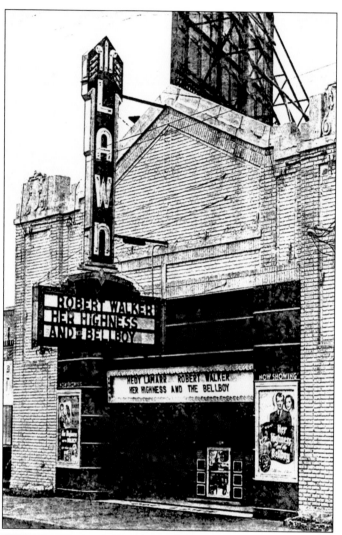

2916 OAK LAWN AVENUE. The 500-seat Oak Lawn Theatre opened on August 7, 1923, with *The Flirt*. After being redecorated and equipped with a new projector, sound system, and Vocalite screen, it reopened on May 3, 1935, as simply the Lawn Theatre with *Hi Nellie!* starring Paul Muni, *La Cucaracha* (a musical short), and an Andy Clyde comedy short. It remained a popular neighborhood cinema until 1949, when it was remodeled for live drama. It was used by several theatrical groups throughout the 1950s, first known as the Playhouse, then the Courtyard Theatre. In the 1960s, it was remodeled for retail, for which it is still used today. (Left, courtesy Texas/ Dallas Archives, Dallas Public Library; programs courtesy of Mary McCord/ Edythe Renshaw Collection on the Performing Arts, Jerry Bywaters Special Collections, Hamon Arts Library, Southern Methodist University.)

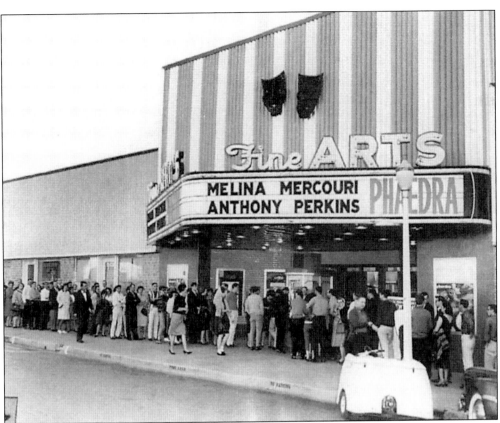

6719 SNIDER PLAZA. The Varsity Theatre, opened in 1929, later became the Fine Arts in 1957. In the early 1970s, it moved from art films to hard-core adult features, and then offered live drama as the Plaza Theatre before being gutted for retail in 1999. (Above, courtesy *Dallas Morning News*; below, courtesy Texas/Dallas Archives, Dallas Public Library.)

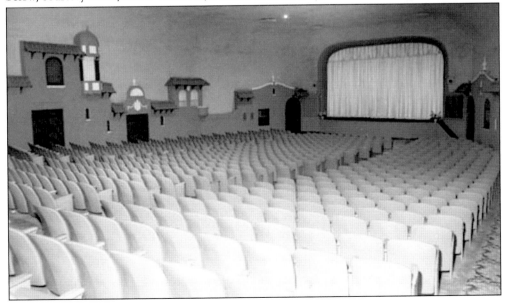

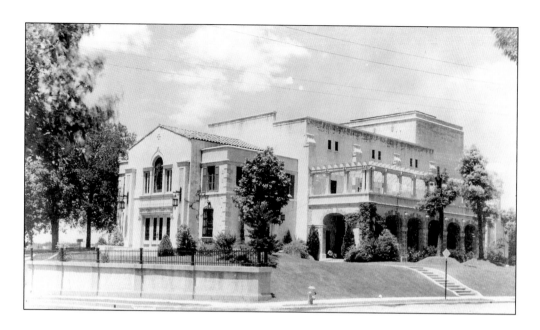

3104 MAPLE AVENUE. The Little Theatre of Dallas opened its new 400-seat Maple Avenue playhouse on April 9, 1928, with a production of Molnar's *The Swan*. The LTOD had come a long way from its very first performance—presented in 1920 in the basement of the First Unitarian Church—to its new $100,000 home, dubbed by the Dallas press as "the house that art built." For its first three years, the LTOD performed in borrowed spaces such as the Unitarian Church, Bush Temple, Forest Avenue High School, and the Scottish Rite Cathedral, until 1923 when after raising $25,000, the group built its own home at 417 Olive Street (illustrated at the bottom right), a simple frame buff-colored auditorium with 242 opera chairs. Two stately cottonwood trees framed the entrance. From this modest playhouse, the LTOD skyrocketed to national prominence—winning the New York Drama League's prestigious Belasco Cup for the nation's best little theatre in 1924, 1925, and 1926. (Top, courtesy Texas/Dallas Archives, Dallas Public Library; below, author's collection.)

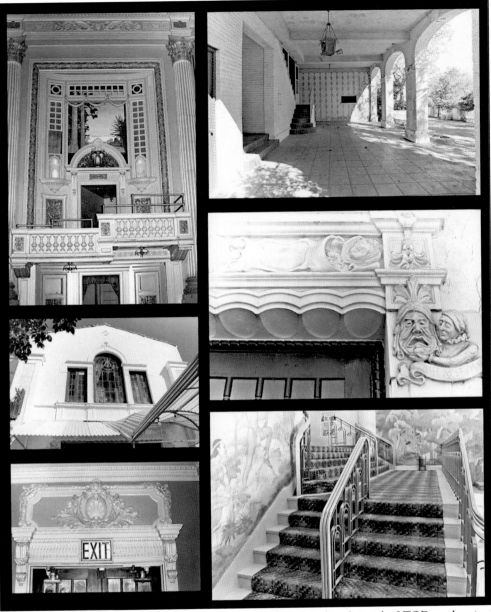

3104 Maple Avenue, Details. Having achieved such national acclaim, the LTOD easily raised $100,000 to construct a magnificent new home. Noted Dallas architect Henry Coke Knight was hired and masterfully combined classic Spanish-Moorish design with American intimacy and comfort. Wrought iron was used liberally inside and out; elaborate, hand-carved walnut doors were used throughout the interior, and the lounge and gallery areas were richly appointed with antique furniture, tapestries, and carpets. The auditorium consisted of deep gold walls and seating, a bright gold, velvet stage curtain, and a grand Moorish chandelier of amber glass and crystal. The LTOD thrived throughout most of the 1930s, but financial difficulties forced it to close in 1943. It then became the Teatro Panamericano, the city's second Spanish-language cinema. It became the Festival Theatre in the mid-1960s. The building was demolished in 1982 for a six-story office building. (Courtesy Texas/Dallas Archives, Dallas Public Library.)

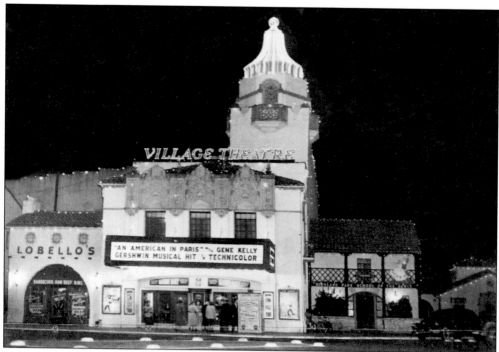

32 HIGHLAND PARK VILLAGE. Opened in 1935, the Village Theatre was part of the first shopping center in America. In the 1970s and 1980s, it was popular for its midnight showings of *The Rocky Horror Picture Show*. Around 1988, it was multiplexed and remodeled with modern Art Deco elements, destroying most of the original design in the process. (Both, courtesy Texas/Dallas Archives, Dallas Public Library.)

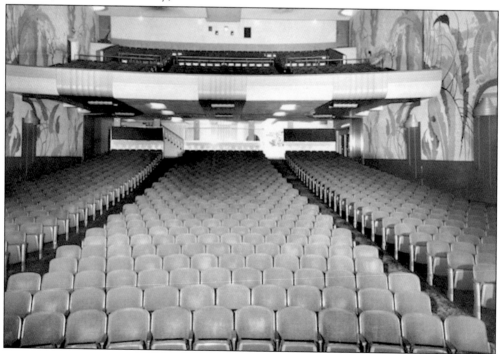

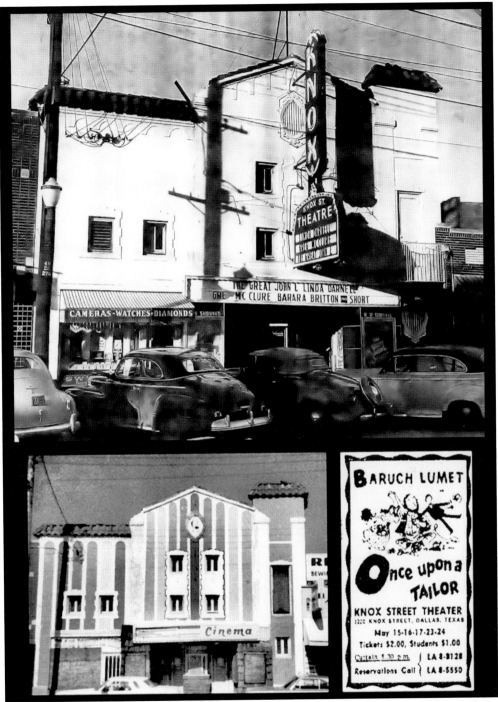

3220 KNOX STREET. The Ro-Nile Theatre opened on August 1, 1922. The owner named the theatre for his wife, Elinor, spelled backward. Renamed the Knox Theatre in 1932, it became the home of Baruch Lumet's Acting School in 1952. Lumet was a star of the Yiddish theatre and father of legendary director Sidney Lumet. It then became a beatnik hangout, followed by a hippie hangout. It was gutted for retail space in the 1990s. (Author's collection.)

5206 MAPLE AVENUE. The 800-seat, stadium-style (tiered rows rather than a balcony) Maple Theatre opened on April 5, 1946, with San Antonio starring Errol Flynn. The facade was covered in glazed tile, and the forward-facing vertical sign measured 30 feet in height. In 1959, it became the home of the Margo Jones Theatre '59 (its final year). The building has since been demolished. (Both, courtesy Texas/Dallas Archives, Dallas Public Library.)

3319 RALEIGH STREET. Opened in September 1947, the Delman Theatre initiated the tradition of showing horror films on New Year's Eve. Later, it became a popular gay disco after closing in the early 1980s. It has since been demolished. (Courtesy Texas/Dallas Archives, Dallas Public Library.)

3419 Oak Lawn Avenue.
When the Melrose Theatre
(right) opened in 1930, it
was said to cost more than
$100,000. In 1947, it was
remodeled to become the
Esquire Theatre (below).
Despite much community
outcry, it was demolished in
1982 for a proposed mid-rise
office building that never
materialized. (Both, courtesy
Texas/Dallas Archives,
Dallas Public Library.)

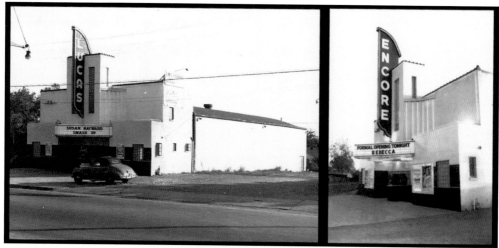

4519 Maple Avenue. The 700-seat Lucas Theatre opened on May 14, 1946, with *Leave Her to Heaven* starring Gene Tierney. After being acquired by the Sack Amusement Company, it reopened on November 24, 1949, as the Encore Theatre, a revival cinema. The opening feature was a revival of the classic Hitchcock thriller *Rebecca* starring Joan Fontaine and Laurence Olivier. The revival format was unsuccessful and the theatre switched to standard second-run fare. By the mid-1950s, the Encore had closed and has since been demolished. (Courtesy Texas/Dallas Archives, Dallas Public Library.)

Drive-In Firsts. The Northwest Highway Drive-In at Hillcrest Avenue, opened in 1941, was the first Dallas drive-in while the Gemini Twin Drive-In, opened in 1965, was the first multiscreen drive-in in Dallas. (Courtesy Dallas Public Library, NewsBank.)

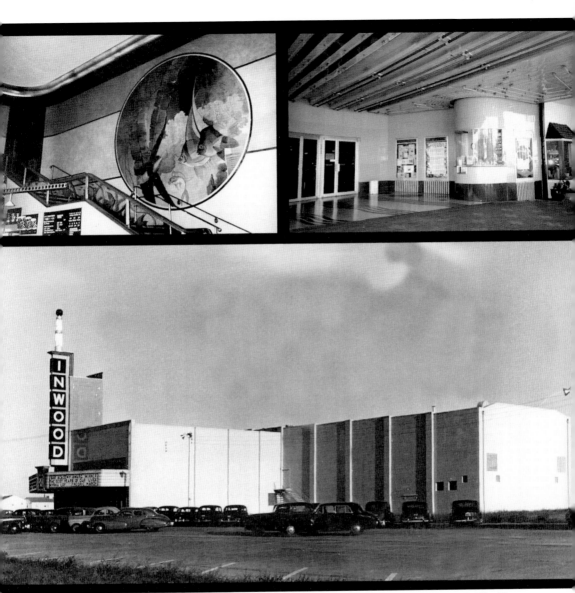

5458 LOVERS LANE. The 1,1000-seat Inwood Theatre reopened on May 16, 1947, with *The Show-Off* starring Red Skelton. The Inwood was frequently home to road shows and other films having long engagements, such as *The Sound of Music*, which played a record 92 weeks. The theatre was triplexed around 1980, but most of the unique design elements were retained, like the murals of tropical fish in the lobby. The Inwood still operates as a cinema. (Top two, author's collection; bottom, courtesy Texas/Dallas Archives, Dallas Public Library.)

3700 FOREST LANE. The 650-seat Park Forest Theatre opened on July 22, 4965, with *A Very Special Favor* starring Leslie Caron and Rock Hudson. Part of the McLendon chain, the Park Forest prided itself on luxury: "foamy" airliner seats, a crystal grain pearlescent screen and stereophonic sound—all for serious film-goers. No discounts were given to children initially. The theatre closed in July 1983 and has been converted into an antique mall. (Photograph by author, 1999.)

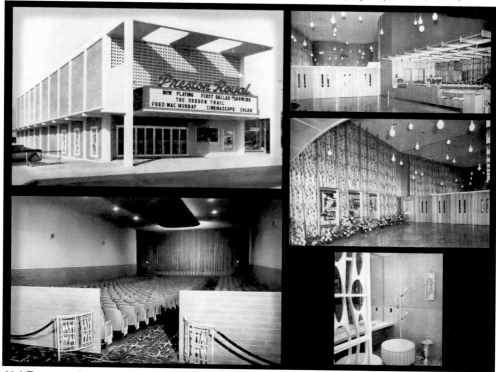

636 PRESTON ROYAL VILLAGE. The ultra-modern 1,000-seat Preston Royal Theatre opened on November 11, 1959, with *The House of Intrigue*. It closed in August 1983 and was gutted for retail. (Courtesy Jim Wheat.)

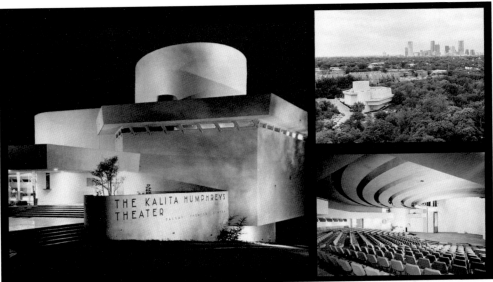

3636 TURTLE CREEK BOULEVARD. Designed by the legendary Frank Lloyd Wright, the Dallas Theatre Center's $1-million, 440-seat Kalita Humphreys Theatre opened on December 27, 1959, with *Of Time and the River*, an adaptation of Thomas Wolfe's autobiographical novel. Built in to a limestone cliff in a scenic wooded area overlooking Turtle Creek, it is one of the last buildings Wright ever designed and is one of only three surviving theatres designed by the renowned architect. The theatre is named for Kalita Humphreys, a South Texas socialite, who had been active in the Dallas theatre scene and was killed in a 1954 plane crash. Her parents donated $120,000 toward the theatre's construction in her memory. The theatre continues to be used for production by the Dallas Theatre Center and other groups. (Courtesy Texas/Dallas Archives, Dallas Public Library.)

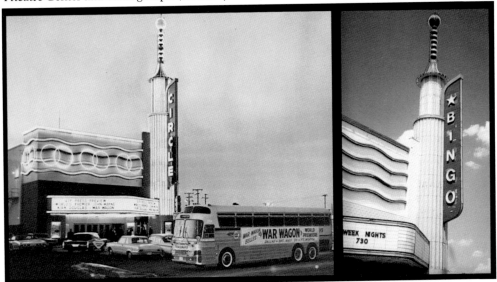

2511 STOREY LANE. The 1,100-seat Circle Theatre opened on October 30, 1947, with live performances by country singer Ernest Tubb and other musicians. Films began the following night with Welcome Stranger starring Bing Crosby. It closed for films around 1970 and was remodeled as a bingo parlor in the 1990s. Much of the original interior and exterior remains intact. (Left, courtesy Texas/Dallas Archives, Dallas Public Library.; right, photograph by the author, 1999.)

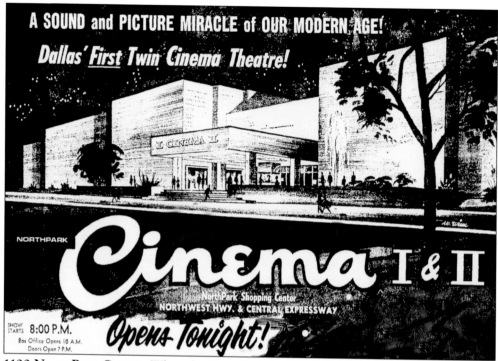

1100 NORTHPARK CENTER. When the NorthPark Cinema I and II opened in 1965, it was one of the first multiplexes in Dallas. It was one of the city's top theatres until closing around 2000. It has been demolished. (Courtesy Dallas Public Library, NewsBank.)

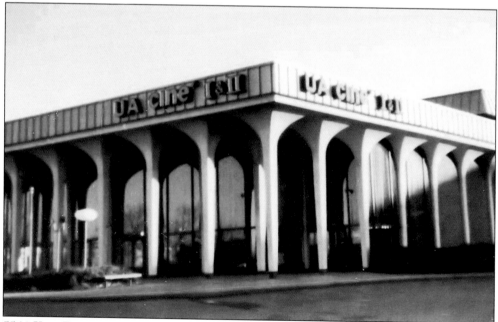

5540 YALE BOULEVARD. Part of the United Artist chain, the Cine 150 opened in 1968; then, in 1973, it was twinned. It remained a top Dallas movie house until closing in the late 1990s. It was demolished around 2002. (Photograph by author, 1979.)

Nine

EPILOGUE

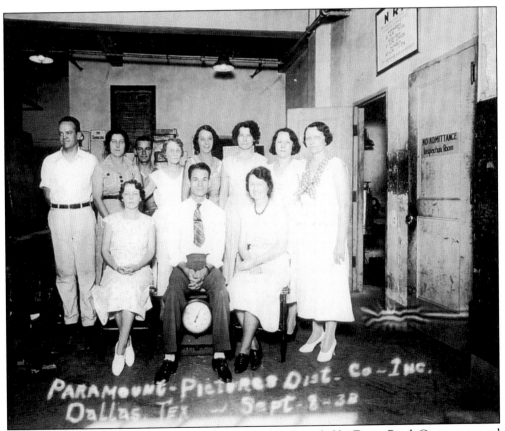

FILM EXCHANGES. The southeastern part of downtown bounded by Ervay, Pearl, Commerce, and Canton Streets housed more than 100 theatre-supported businesses, such as concession wholesalers, theatre architects, poster services, theatre supply houses, and film exchanges. Members of the Paramount Pictures film exchange are shown here. (Courtesy the George Blackburn family.)

NEIGHBORHOOD THEATRES. Pictured is a sampling of advertisements for films that played at the many Dallas neighborhood theatres. These theatres also served as community gathering centers: children would join their buddies here on Saturday afternoons, teens would gather

and socialize on Saturday nights, and adults might bump into and catch up with a neighbor they haven't seen for more than a year. What becomes of communities when such gathering centers vanish? (Author's collection.)

DINNER THEATRES. Dinner theatres became very popular in the late 1960s. By the early 1980s, most were gone. (Author's collection.)

THEATRES NOT INCLUDED. Several theatres were not discussed in this book due to the lack of material found to adequately tell their stories. (Author's collection.)

MORTON H. MEYERSON SYMPHONY CENTER. The 2,062-seat Meyerson Symphony Center opened in September 1989 and has come to be regarded as one of the world's finest symphony halls. Designed by renowned architect I.M. Pei and acoustician Russell Johnson, the edifice cost $50 million to complete. In addition to multimillion-dollar gifts from H. Ross Perot and the Eugene McDermott Foundation, much of the money came in the form of small donations from individual Dallas citizens. (Both, courtesy Dallas Symphony Orchestra.)

WINSPEAR OPERA HOUSE. Completed in 2009, the 2,200-seat Margot and Bill Winspear Opera House cost an estimated $180 million, about 90 percent of which came from private monies. It is Dallas's first opera house since 1917. (Both, courtesy AT&T Performing Arts Center.)

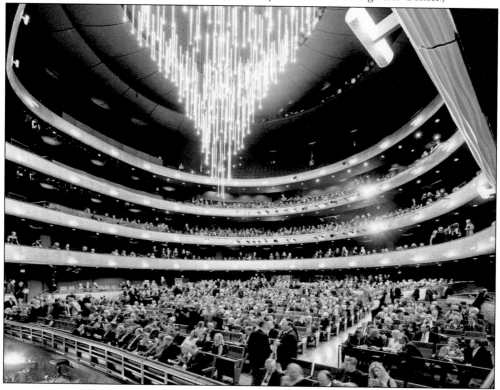

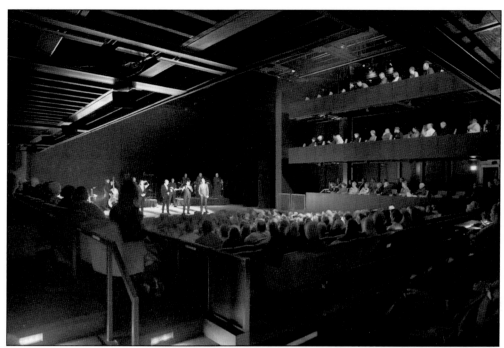

DEE AND CHARLES WYLY THEATRE. If the Transformers had a theatre, this would be it. Opened in 2009, the 600-seat Wyly Theatre's innovative design allows the stage and house to be reconfigured in almost any way, depending on the type of performance. The Wyly is the new home of the Dallas Theatre Center as well as a number of theatre and dance groups. The Wyly Theatre and the Winspear Opera House are two of several structures and spaces on 10 acres in the Dallas Arts District, better known as the AT&T Performing Arts Center. (Both, courtesy AT&T Performing Arts Center.)

DALLAS CHILDREN'S THEATRE. After performing in borrowed spaces for more than 30 years, the Dallas Children's Theatre (DCT) finally has a home of its own in a former bowling alley. (Lower photograph by Karen Almond.)

THEATRE SPACES. Smaller and younger theatre groups are inevitably confronted with the challenges of finding affordable performance space. Two smaller Dallas theatre companies found innovative ways to deal with this problem. TeCo found an old, nondescript Oak Cliff building in bad shape after years as an automobile shop and warehouse. After some research, TeCo discovered that the building had been the old Bluebird Theatre, a silent-film theatre that closed in 1923. While funds were still necessary to return the building to theatrical use, TeCo's research was undoubtedly useful in generating interest in the community and media and, by default, assisted with fundraising. Teatro Dallas found a reasonably priced commercial building in an area similar to a business park. Initially, it only needed it for rehearsals, but over time, the rehearsal space was transformed into a performance space. (Left, photograph by Leticia Alaniz, courtesy Cora Cardona and Teatro Dallas; right, photograph by Jacquie Patrick, courtesy Teresa Coleman Wash and TeCo Theatrical Productions.)

MUSIC VENUES. The Granada Theatre (pictured here) has been a thriving music venue for more than 10 years. The Kessler Theatre has also become a similar venue with great success. (Photograph by Bill Ellison.)